Fernando Botero

Fernando Botero

Hirshhorn Museum and Sculpture Garden, Smithsonian Institution
Cynthia Jaffee McCabe

Smithsonian Institution Press
Washington, D.C.

Front cover: *The Musicians,* 1979 (catalog number 66)
Back cover: *Our Lady of New York,* 1966 (catalog number 6)

Exhibition Dates
Hirshhorn Museum and Sculpture Garden, Smithsonian Institution,
Washington, D.C., December 20, 1979–February 10, 1980
Art Museum of South Texas, Corpus Christi, March 27–May 10, 1980

Library of Congress Cataloging in Publication Data
McCabe, Cynthia Jaffee.
 Fernando Botero: Hirshhorn Museum and Sculpture
Garden, Smithsonian Institution.
 Catalog of an exhibition held at the Hirshhorn Museum
and Sculpture Garden, Washington, D.C., Dec. 20, 1979–
Feb. 10, 1980 and at the Art Museum of South Texas,
Corpus Christi, Mar. 27–May 10, 1980.
 Bibliography: p.
 1. Botero, Fernando, 1932– —Exhibitions.
I. Botero, Fernando, 1932– II. Hirshhorn Museum and
Sculpture Garden. III. Art Museum of South Texas.
ND379.B6A4 1979 709'.2'4 79–607807

ISBN 0-87474-630-2

This catalog was produced by the Smithsonian Institution Press,
Washington, D.C. Printed by Wolk Press, Inc., Baltimore, Md.
Set in VIP Frutiger by Composition Systems Inc., Arlington, Va.
The text paper is eighty-pound Lustro Offset Enamel Dull with
Holliston Roxite Vellum cover and Multicolor Antique endpapers.
Designed by Ray Komai.

Contents

Lenders to the Exhibition

Joachim Jean Aberbach, New York
Julian J. Aberbach, Paris
The Abrams Family Collection, New York
Mr. and Mrs. Miguel Aranguren, Arlington, Virginia
David Barrett, New York
Mr. and Mrs. E. A. Bergman, Chicago
Mr. and Mrs. Leigh B. Block, Chicago
Fernando Botero, Paris
Juan David Botero, Bogotá
Mr. and Mrs. Mauricio Botero, Madrid
Ambassador and Mrs. José Camacho-Lorenzana, Washington, D.C.
Dr. Jack E. Chachkes, New York
Mr. and Mrs. Peter Findlay, New York
Mr. and Mrs. Mackenzie Gordon, Washington, D.C.
Mr. and Mrs. Samuel M. Greenbaum, Washington, D.C.
Jane and Manuel Greer, New York
Mr. and Mrs. Carlos Haime, New York
Delmar D. Hendricks, New York
H. J. Kicherer, Rockville, Maryland
Sydney and Frances Lewis, Richmond, Virginia
Mr. and Mrs. Diego Llorente, Bogotá
Patrick B. McGinnis, New York
Mr. and Mrs. Thomas M. Messer, New York
Metromedia, Inc., Los Angeles
Paul S. Newman
Beatrice Perry, New York
Mr. and Mrs. N. L. Pines, New York
Julio Mario Santo Domingo, New York
Mr. and Mrs. Eugene S. Schweig, Jr., St. Louis, Missouri
Mr. and Mrs. Jerome L. Stern, New York
Mr. and Mrs. Stanley Westreich, Bethesda, Maryland
Mrs. Shelby White, New York
Mr. and Mrs. Sidney S. Zlotnick, Washington, D.C.
Three anonymous lenders

The Baltimore Museum of Art
Hirshhorn Museum and Sculpture Garden, Smithsonian Institution, Washington, D.C.
The Lowe Art Museum, The University of Miami, Coral Gables, Florida
Milwaukee Art Center
Museum of Art, Rhode Island School of Design, Providence
The Museum of Modern Art, New York
The Solomon R. Guggenheim Museum, New York

Aberbach Fine Art, New York
Galería Botello, San Juan, Puerto Rico
Marlborough Gallery, New York

Foreword

Although Fernando Botero is a native of Colombia, it is not as a South American artist that he has made his reputation, but as an artist of international distinction who has lived and worked for most of his life in the great art capitals of the world and currently makes Paris his home. His representation in museum and private collections throughout Europe and the Americas is suggested by the list of lenders to this exhibition, which is an index to the wide audience his work enjoys. Although Botero exhibits frequently in the United States, this exhibition marks his first major museum retrospective here.

Once observed, Botero's unique style is instantly recognizable. Whether a bishop, an apple, or a presidential family, his subjects exist in a universe populated exclusively by oddly exaggerated pneumatic beings. Seemingly larger than life, at once stolid and voluptuous, they skirt the grotesque and establish themselves as elements of a mordantly humorous reality. Our initial reaction to this piquant alliance of flesh and spirit, of sensuality and hauteur, may be one of offended surprise, but it quickly gives way to cheerful acceptance. This is due, in large part, to the convincing way in which Botero's painterly volumes are realized. His sense of both color and form relates him in a subtle way to a Latin-American strain of Hispanic painting that echoes Pre-Columbian, classical Spanish, and Spanish Colonial art.

Botero walks the thin line that separates high art from caricature and succeeds in merging both. His satire is marked by a sense of the absurd and an assault on what we hold to be timeless canons of beauty and ideal proportion. His paraphrases of established masterpieces provoke smiles but also reveal a profound comprehension of and a vital link with the past—on his own irreverent terms, of course. He is not mocking; on the contrary, he is paying homage, with a sort of reverential recycling, a process not unusual in modernist art (consider, for example, Picasso's preoccupation with Velázquez). Both the cruelty and satire of Spanish painting—with its dwarfs, beggars, martyrs, and nightmares—are reflected in Botero's swollen cast of characters. Like Picasso, he is also attracted to the polished and voluminous forms of Ingres, and, indeed, in their ponderous grace, some of his figures are not unrelated to those of Picasso's classical period.

Pluralism has reintroduced us to the variations possible in figurative art. There is an aesthetic expansiveness at this moment that, in spirit at least, parallels the joie de vivre and the sensuality of Botero's art. But beneath the humor and eroticism, we can discern a troubling insight into the extravagance, vanity, and greed of contemporary life.

Although Cynthia Jaffee McCabe, curator of this exhibition, has extended our collective thanks elsewhere in this catalog, I would like to single out Mr. Botero, who has good naturedly suffered an inquisition of interviews and requests of all kinds, meeting these demands in a spirit of gracious cooperation. Without his active participation this exhibition would not have been possible.

Abram Lerner
Director

Acknowledgments

In the long "springtime of the patriarch" during which this exhibition took form, the dark, cruel melancholy of much Colombian art and literature permeated my world. A few who helped me then must, in gratitude, go unnamed. Among the others to whom my thanks are due are Abram Lerner, for twelve years my director, who proposed this exhibition, and Fernando Botero who, with wit, encouraging words, and forbearance, worked with me toward its realization.

The exhibition *Fernando Botero* is the product of collaborative efforts on three continents. With respect to the artist's homeland, special acknowledgment must be given to His Excellency Dr. Virgilio Barco, ambassador, and Cecilia Isaacs, cultural attaché, Embassy of Colombia in Washington, D.C. In addition, I wish to thank Juan David Botero, the artist's brother, and Nohra Haime, art consultant, who, while compiling a catalogue raisonné of Botero's paintings, undertook a special research assignment for this project.

Also assisting with documentation relating to Colombia were: Federico Clarkson, director, and Claudia Granja, assistant director, Colombian Government Trade Bureau, New York; Gloria Zea de Uribe, director, Instituto Colombiano de Cultura, Ministerio de Educación Nacional, Bogotá; Sebastian Romero, chief, Visual Arts Section, Pilar Moreno de Angel, director, Biblioteca Nacional, and Cecilia Galan de Medina, Museo de Arte Moderno, all also of the Instituto Colombiano de Cultura;

Roger Stone, director, and Sharon L. Schultz, assistant director, Visual Arts Program, Center for Inter-American Relations, New York; José Gómez-Sicre, director, and Jane Harmon de Ayora, exhibitions coordinator, Museum of Modern Art of Latin America, Organization of American States, Washington, D.C.; Jaime Duarte French, director, Biblioteca Luis-Angel Arango, Banco de la República, Bogotá; and James Findlay, Latin American Archive, Library, Museum of Modern Art, New York.

A special note of appreciation is due to the lenders whose names appear at the beginning of this catalog. I am grateful, too, to Beatrice Perry, Grace Hartigan, and Marina Ospina, among others, who shared their recollections with me. To all the individuals who informed me about works by Botero, provided access to them, helped with Spanish-English translations, traced ownership records, or supplied photographs, I also wish to express my thanks.

Pierre Levai and Jack Mognaz of Marlborough Gallery, New York, have consistently supported this project; Elizabeth Ross and Vibeke Levy of the Marlborough staff were also especially helpful. Other dealers whose cooperation was most valuable include: Joachim Jean Aberbach and Allen Harrill, Aberbach Fine Art, New York; Rachel Adler, Adler/Castillo Gallery, Caracas and New York; Dieter Brusberg and Karin Brandhorst, Galerie Brusberg, Hanover, Germany; Walter Engel, Walter Engel Gallery, Toronto; Peter Findlay, New York; Ruth Freudman, Sotheby Parke Bernet Inc., New York; Claude Bernard Haime, Galerie Claude Bernard, Paris; Luis Lastra, Washington, D.C. (who also helped with translations); Ramon Osuna, Osuna Gallery, Washington, D.C.; and Dorothea Tannenbaum, Catani-Tannenbaum Gallery, New York.

Like all major exhibitions, *Fernando Botero* is the result of the collaborative endeavors of many persons at the Hirshhorn Museum. I would like to express special appreciation to: Linda Cabe, summer intern from the University of North Carolina, Chapel Hill, who enthusiastically helped me to see the catalog through its final stages; Sareen R. Gerson, my research assistant during the exhibition's initial planning phase, who coordinated loan requests and related queries; Librarian Anna Brooke, who compiled the exhibition lists and bibliographies, and her assistants Carole Weil and Monica Longen; Bette Walker, who expertly typed the manuscript, with support from Deborah Geoffray, Paul Engelstad, and Stephanie Hughes; and Writer-Editor Nancy Grubb, an incisive professional.

Other staff members I wish to acknowledge include: Photographers John Tennant and Lee Stalsworth and Photo Archivist Francie Woltz; Registrar Douglas Robinson and his staff, particularly Rosemary DeRosa; Chief Joseph Shannon, Assistant Chief Ed Schiesser, Mary Jickling (for translations), and the Department of Exhibits and Design; Docent Isabel Langsdorf (for translations); Chief Curator Charles W. Millard; Administrator Nancy F. Kirkpatrick; Deputy Director Stephen E. Weil; and my colleagues in the Department of Painting and Sculpture.

Richard T. Conroy, deputy director, Smithsonian Institution Office of International Activities, and James Symington, director, and Carole S. Rader, associate director, Smithsonian Institution Office of Membership and Development, also advised me on this project. Maureen Jacoby, managing editor; Janet Stratton, design manager; and Kathleen Preciado, editor, of the Smithsonian Institution Press played crucial roles in the production of the catalog, as did its designer, Ray Komai.

Finally, Cathleen S. Gallander, director, and the staff of the Art Museum of South Texas deserve a note of appreciation for sharing in this exciting presentation.

C.J.M.

Fernando Botero

Cynthia Jaffee McCabe

"Why do you paint fat figures?" Botero has been asked. "I don't. They look rather slim to me," was his reply. "My subject matter is sometimes satirical," he continued, "but these 'puffed-up' personalities are being 'puffed' to give them sensuality. . . . In art as long as you have ideas and think, you are bound to deform nature. Art is deformation. There are no works of art that are truly 'realistic.'"[1]

An awesomely prolific artist, Fernando Botero has attracted serious critical attention since the late 1950s. Yet his name is far better known in Europe and Latin America than in the United States. After a youth spent in Medellín, Colombia, he has lived for extended periods in Madrid, Florence, Mexico City, and New York, and now resides in Paris. At age forty-seven, Botero belongs to the first generation of artists to

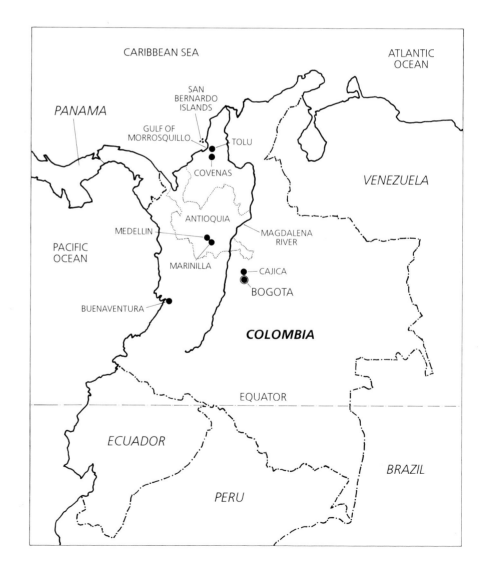

arrive at creative maturity in the post-World War II era. Like his globe-trotting contemporaries Christo, Marisol, Yaacov Agam, and Mark di Suvero, he has an audience and a perspective that are international.

While reacting vehemently against the classification of artists by region or hemisphere, Botero still identifies strongly with his homeland.[2] Asked to describe his feelings about Latin America, he replies:

We have a great Platonic relationship. Latin America is one of the few places left in the world which can be transformed into myths. People have a cloudy idea about Latin America and that is a good thing for an artist.[3]

Medellín, where Fernando Botero Angulo was born in 1932, is Colombia's second largest city and its commercial and industrial center. Located on a plain in the Colombian Andes, in the department of Antioquia, Medellín was isolated from the outside world during Fernando's youth. The roads were so primitive that his father, a salesman, covered the surrounding territory primarily on horseback. The remoteness of Medellín was characteristic of the situation throughout Colombia. The only South American country with both Atlantic and Pacific coasts, it has a fierce internal topography, with abrupt juxtapositions of plains, jungles, Andean ranges, and Amazon swampland. Governed by Spain as part of the Viceroyalty of New Granada until attaining independence in 1810, it remains one of the most staunchly Catholic countries on the continent. According to cultural historian Jean Franco:

Venezuela and Colombia illustrate the phenomenon of the survival of social structures and ways of life which have much in common with medieval Europe. The remarkable feature, particularly of contemporary Colombian writing, is the way that novelists have made an imaginative effort

to explore creatively a situation where the archaic survives alongside the most modern instruments and inventions.[4]

This "remarkable feature" is as evident in the paintings of Fernando Botero as it is in the novels of the Colombian writer Gabriel García Márquez, with whom he is often compared.

Even more than literature, the visual arts were tied to ornate Colonial prototypes; according to Marta Traba, one of Colombia's leading art critics:

The national tendency being naturally toward excess, Botero's ability to justify incongruity and to locate the hideous gave full expression to the lack of stability of any sort and the consistent anti-classicism of the country. . . . And certainly Colombian art was suffering, until the appearance of Fernando Botero, from a notorious lack of directness and brutality.[5]

Botero began his career at sixteen as an illustrator for the Sunday literary supplement of Medellín's leading newspaper, *El Colombiano*. His drawings (see fig. 1) clearly demonstrate his facility as a draftsman, as well as the influence of the twentieth-century Mexican muralists Diego Rivera, David Alfaro Siqueiros, and José Clemente Orozco and their local acolyte, Pedro Nel Gómez. Botero was also paint-

fig. 1
Illustration by Botero from the Sunday literary supplement of *El Colombiano*, May 8, 1949, p. 2

ing during this period, and his *Woman Crying*, 1949 [8],* like his other, mostly larger, watercolors from the late '40s, is also indebted to Orozco. While the sensuous color is Botero's own, the pervading sentimentality reflects an intense interest in César Vallejo's melancholy poems. With his close friends—Carlos Jiménez Gómez, Gonzalo Arango, and Jaime Piedrahita[6]— and Medellín's other young intellectuals, Botero absorbed the works of Vallejo, Federico García Lorca, Pablo Neruda, and Miguel Angel Asturias as well as those of a fellow townsman, Carlos Castro Saavedra.

At this time Botero had little knowledge of original works of art:

I have seen Colonial churches since I was very small, Colonial painting and polychrome sculpture. And that was all I saw. There was not a single modern painting in any museum, not a Picasso, not a Braque, not a Chagall. The museums had Colombian painters from the eighteenth century and, of course, I saw Pre-Columbian art. That was my exposure.[7]

Nonetheless, information about European painting prior to 1940 did reach Medellín via books, magazines, and reproductions. From an Argentine history of modern art by Julio Payro, Botero first learned about Pablo Picasso. In the July 17, 1949, issue of *El Colombiano* he published an article called "Picasso y la inconformidad en el arte" ("Picasso and Nonconformity in Art"):

Cubism is a wide open window through which we comprehend the destruction of individualism through communality. . . .

Through his images, Picasso has united everything, the world, the most subtle, the most tenebrous. . . .

And so, in quiet genius, his periods succeed each other: black, brutal and aggressive; and his "gigantomaquía," monumental and sensual. . . . they are many united in just one man: "Picasso."[8]

It was an unpropitious time for a seventeen-year-old to express new ideas in a public forum. In 1948, bloody rioting in Bogotá had shattered an unprecedented

*Numbers in brackets refer to catalog entries.

12 four-decade period of democratic rule and relative peace in Colombia:

It was very, very tough. We were going through what was called "La Violencia," which left 300,000 people killed in ten years. Even in Medellín it was dangerous. People would disappear; the police would take them, and you never knew about it. It was a state of undeclared war.

Botero's newspaper illustrations of nudes had already brought warnings from the principal of his Jesuit secondary school. The appearance of his article on Picasso and nonconformity led swiftly to his expulsion. Undaunted, he published a second article a month later on Salvador Dalí entitled "Anatomía de una locura" ("Anatomy of a Madman").[9] By then, however, Botero had been sent to finish the semester at a grim government school in the nearby town of Marinilla, where "the atmosphere was very Colombian, the roofs, the houses, just like they are in my paintings. These small towns, the little bourgeois cities at that time, this is where my subject matter comes from."

At semester's end, Botero took his first trip beyond Antioquia. Traveling by railroad north to the Magdalena River, he then took an eight-day journey on a "primitive, Mississippi-kind of boat," which brought him to Barranquilla on the Caribbean coast. After his vacation he returned to Medellín for a final year of secondary school at the Liceo de la Universidad de Antioquia, and then, in January 1951, having received his baccalaureate, he moved to Bogotá.

In Bogotá, Botero discovered, there was a real avant-garde, especially in literature. At a café called the "Automática," the young artist from Medellín could watch and exchange a few words with "the big names of culture at the moment," among them writer Jorge Zalamea, who

had been ambassador to Mexico and a close friend of García Lorca's.

Five months after his arrival in the capital Botero had his first solo exhibition, at the Galerías de Arte Foto-Estudio Leo Matiz. The catalog listed twenty-five watercolors, gouaches, drawings, and oils; *Woman Crying* was reproduced on the cover. Responses were encouraging, and with the money he earned, Botero moved to the Caribbean village of Tolú where, he had determined, his funds would last the longest.

Also, Tolú promised to be Colombia's Tahiti, and Botero had visions of being the Gauguin of Latin America. While clearly influenced by Picasso's blue and rose periods, his paintings of basket-laden Caribbean natives going about daily tasks or relaxing were preeminently Gauguinesque. His palette of bright yellows, pinks, and blues reflected the tropical sun. But Botero soon realized that "La Violencia" extended even to Tolú. After seeing a man suspended from a pole like a tiger captured at the chase, he painted *In Front of the Sea,* 1952 (fig. 2). It is his only work created out of the anger of a specific moment, and even here the scene is subdued and stylized.

fig. 2
Fernando Botero
In Front of the Sea (Frente al mar), 1952
Oil on canvas, 130 x 110 (51 x 43)
Dr. Porras Omaña, Caracas

ESTUDIO ACTUAL

Botero's paintings of primitive, "pure," Tolú; of Coveñas, a nearby coastal town; and of the islands of San Bernardo appealed to the nationalist sentiments then prevailing in Bogotá. His second show at Matiz's gallery, held in May 1952, shortly after his return to the capital, was sold out; the artist made 7,000 pesos (roughly 2,000 dollars). Two months later he received another 7,000 pesos as second prize for *In Front of the Sea* at Colombia's prestigious annual Salón. He now had enough money to take the traditional art student's journey to Europe.

With a group of Colombian colleagues, Botero sailed to Barcelona from the port of Buenaventura in August 1952. The eighteen-day voyage was made third cabin in the company of deported immigrants. Interested exclusively in modern art, he spent only three or four days visiting Barcelona's museums, then took a train to Madrid.

Enrolled at the Academia San Fernando, Botero quickly became immersed in studying his "first real works of art" at the Prado. He identified immediately with Goya and Velázquez: the mores and mannerisms of the Spanish kings, queens, and courtiers they portrayed were still being emulated in his own homeland.

I took a room in front of the Prado; I was working very hard. I got up at seven o'clock and by eight I was in the museum where five or six young artists were sketching in front of Greek casts. At ten to San Fernando; after lunch I went to the Prado, then back to the school.

Everyone in the school wanted to have a style; I wanted to get a craft.

The professors didn't talk to you; they were like God. When you didn't know, you believed them, but they were third-rate painters. The School of Madrid in the time of Franco had a very strange avant-garde.

For a while Botero's desire to spend more time copying at the Prado was thwarted by a museum policy that allotted copyists twenty days per painting and permitted no more than one easel to be

set up in any gallery. However, he made friends with an especially proficient professional copyist who was willing to share the allotted time with him. Since copies after Velázquez or Titian had a constant market among Madrid's tourists, Botero was able to supplement his funds brought from Bogotá while absorbing the lessons of the Old Masters.

After two semesters in Madrid, Botero traveled to Paris.[10] With Ricardo Iragorri, a film-maker friend from Colombia, he rented a small apartment on the place des Vosges on the Right Bank. While well aware that most artists from abroad were frenetically seeking Paris gallery connections, Botero had a very different objective. Whereas, only eight months earlier, he had deliberately bypassed an exhibition in Barcelona of Italian Primitives, "the painters with the gold frames," now he paid only a perfunctory visit to the Musée d'Art Moderne: his sole interest was in studying the works of art at the Louvre. He did little sketching in Paris; it was, after all, vacation time and his first visit to the French capital. At summer's end, the roommates traveled together to Florence, where Botero stayed, while Iragorri continued on to Rome.

Once in Florence, Botero found a spacious, high-ceilinged studio at 9 via Panicale, which had formerly belonged to Giovanni Fattori, leader of the group of nineteenth-century Italian painters called the Macchiaioli ("spot-painters").[11] Botero was determined to study fresco technique at the Accademia San Marco. Having enrolled in Giovanni Colacicchi's course, he soon realized that instruction was minimal; Colacicchi appeared only once to impart the traditional formula, which consisted of adding sand to dry pigments and applying the mixture to a wet plaster surface. It was the last time Botero sought formal training in art.

He worked each morning on frescoes, copying portions of works by Giotto and Andrea del Castagno. In the afternoons he painted in oils in his studio. Each new enthusiasm—Piero della Francesca, Paolo Uccello, Masaccio—was reflected in his canvases; he seemed to have an enormous capacity to absorb the influence of others. *The Departure,* 1953 [9], is typical of his Italian paintings: the horses come from Uccello, the overall stillness and suggestion of mystery from Piero and Giorgio de Chirico, the stolid figure from his own Colombian past.

Roberto Longhi's lectures at the Università degli Studi di Firenze intensified Botero's obsession with the quattrocento. He made motorcycle trips throughout most of northern Italy to see the original Italian masterpieces and was enthralled by an exhibition of works by Piero, Castagno, Uccello, and Domenico Veneziano at the Palazzo Strozzi in Florence:

What fascinates me about Italian art is that through the approach that they had it was possible to give color and form equal importance. With Piero, he goes beyond color to a mystery, to something you can never get completely in your mind; he goes to the center of vision.

Botero returned to Bogotá in March 1955, and two months later exhibited the twenty canvases he had brought back from Florence. Reactions ranged from disbelief to overt hostility, with critics observing that all the unassimilated influences garnered during a two-and-a-half-year European sojourn were manifest in these paintings. None of the works was sold. It was the only time in Botero's adult life that he was unable to support himself as an artist. At his brother Juan David's suggestion he tried selling automobile tires; again sales were nonexistent. Eventually he found work doing magazine layouts. At the beginning of 1956 he moved to Mexico City.

In Mexico, Botero began to work his way through to an individual style. *The Rooster,* 1956 [21], with its fragmentation, uneasily shows the influence of Alejandro Obregón, Colombia's pioneer modernist; but *Still Life with Mandolin* (Fernando Duque Collection, Bogotá) is a more successful transitional work. It was in *Still Life with Mandolin* that the artist first sensed the possibility of inflating his forms: "it was like a small door that I went through to get to another room."

In Mexico City, Botero was able to earn a living from studio sales, especially to vacationing Colombians. Here, as elsewhere, he knew virtually everyone in the artistic community but he found his closest friends outside that milieu. He met, among others, the Mexican painters Rufino Tamayo and José Luis Cuevas (see fig. 3), who both may have influenced his work, although all three artists drew inspiration from common Latin American and Pre-Columbian sources.

fig. 3
José Luis Cuevas (Mexican, b. 1933)
Assaulted Woman VII, 1959
Gouache on paper, 101.6 x 68 (40 x 26)
Hirshhorn Museum and Sculpture Garden, Smithsonian Institution, Washington, D.C.

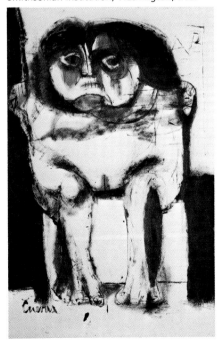

A solo exhibition at the Pan American Union in Washington, D.C., in April 1957 was the occasion for Botero's first visit to the United States. From Mexico City he flew directly to New York, where for a week he made the mandatory museum rounds. He had heard about Jackson Pollock during his student days in Florence and now had his first glimpse of the Abstract Expressionists' world. He spent the next three weeks in Washington, where he felt so isolated that "it was like still being in Latin America; I had no English and no money." José Gómez-Sicre, longtime director of the Visual Arts Division of the Organization of American States, found him a tiny room on Massachusetts Avenue, north of Dupont Circle. Cuevas, too, was in Washington, and Gómez-Sicre made no secret of his preference for the Mexican nor of his belief that Botero "was the most intelligent copyist of Cuevas," with other obvious roots in the work of Colombians Enrico Grau and Obregón. More beneficial was time spent with José Bermudez, a painter from Bogotá then working at the OAS, and his Argentine wife, Jenny, who was also an artist; "they were fascinated by the American art, by Abstract Expressionism. We had long conversations, and I got to know more or less what it was all about."

With works priced from thirty to one hundred seventy-five dollars, Botero's show sold out, largely to members of the OAS staff. While Leslie Judd Portner of the *Washington Post and Times Herald* was moderately encouraging,[12] the exhibition was otherwise ignored. Botero, however, did make a number of useful contacts, including Tania Gres, who was later to open a gallery in Washington.

With news of his "successful" United States exhibition preceding him, Botero returned to Bogotá. The next three and a half years were probably the most innovative of his career. Botero considers *The Sleeping Bishop,* 1957 [1], to be his first confrontation with "the problem of portraying contemporary subject matter." Clergy, he discovered, could be useful in this regard:

The reason I painted priests is very clear. I was completely involved and in love with the quattrocento. But of course I couldn't paint the personality of the quattrocento now. Priests were somehow contemporary but they were out of the Middle Ages.

His self-confidence grew. Within a year, he submitted the large, freely interpreted *Camera degli Sposi (Homage to Mantegna) I* [10] to the Colombian Salón. When word of its impending rejection by the jurors reached the editor of *Semana,* the country's version of *Time,* he chose a full-page reproduction of it to accompany an article on the Salón.[13] Instead of being rejected, the painting was awarded first prize.

Camera degli Sposi (Homage to Mantegna) I was among the works Botero brought with him for his second Washington exhibition at the Gres Gallery in October 1958. In this unique gallery, which existed only from late 1957 to 1961, Botero's work was seen in an international context for the first time. Others shown at the Gres included Larry Rivers, Louise Nevelson, Grace Hartigan, and Dorothy Dehner from the United States, Karel Appel from The Netherlands, Wojciech Fangor from Poland, and Antoni Tàpies from Spain. During his 1958 visit to the United States, Botero, already fluent in French and Italian as well as Spanish, learned enough English to appear on a television interview program. "He was witty and very, very charming," recalls Beatrice Perry, director of the Gres, with whom he maintained a lively correspon-

dence over the next years (fig. 4).[14] His works, such as *Boy with Mandolin,* were bright and unusual, and the show almost sold out on opening night.

Prior to leaving for Washington, Botero had been appointed professor at the Escuela de Bellas Artes in Bogotá; the twenty-six-year-old artist, husband, and father now had a stable income. Increasingly, he was being acknowledged as the most important young artist in Colombia. At García Márquez's insistence, he illustrated "La siesta del martes" ("Tuesday Siesta") in *El Tiempo,* Colombia's leading newspaper;[15] author and artist each received an unprecedented one thousand pesos (less than two hundred dollars) for his work. When Jorge Zalamea wrote a laudatory article on him in the periodical *Cromos,*[16] "it was like a consecration."

As a first-prize winner, Botero no longer had to submit his annual entry to the Salón jury. In 1959, his Salón piece was *Apotheosis of Ramón Hoyos* [56], which, he states, was Colombia's first contribution to Pop Art. Two years before the movement's emergence in New York, he painted this large canvas of Hoyos, the country's

fig. 4
Letter from Botero to Beatrice Perry, 1958

champion cyclist, with Colombian flag triumphantly held aloft, riding over a mound of defeated contenders and their bicycles.

Like *Camera degli Sposi (Homage to Mantegna) I* and *Apotheosis of Ramón Hoyos,* his Mona Lisas also caused a sensation. In 1959 he produced several Boteroesque variants of this icon of Western art, one of which was acquired two years later by the Museum of Modern Art in New York. In response to a museum questionnaire about *Mona Lisa, Age Twelve* [12], Botero wrote:

Leonardo da Vinci's Mona Lisa is so popular that perhaps it is no longer art. For me, it is just like a movie star or a football player. Hence, an obvious satirical element in my painting. While doing the painting, I discovered that what is important is not the smile but the eyes.[17]

Today the artist believes that this statement "without knowing it was a little like the philosophy of Pop Art. Another thing I found important was that—with a bold approach—the head is so overblown that it takes up the entire space. I'm not saying that I created this in American art but I wasn't taking it from the American artists." Certainly, *Apotheosis of Ramón Hoyos* and the Mona Lisas, done in Bogotá, predated Botero's knowledge of Pop Art. Even during his first months in New York in 1960 he was unaware of what Rauschenberg, Warhol, and the other Pop artists were producing. In February 1961, on the advice of a Colombian friend, Marina Ospina, he visited Lichtenstein's first show at the Leo Castelli Gallery. Both he and Lichtenstein seem to share a common philosophy, "to take the banality of life and turn it into art."

In contrast to the Pop-confidence of the Mona Lisas, Botero's works from late 1959 and 1960 were subdued. One somewhat disturbing theme was *El Niño de Vallecas (after Velázquez)* [see 11]. The works in this series show unexpectedly hesitant brushwork and are virtually monochromatic. Painted in Bogotá in little more than a month, they reflect personal upheaval (the dissolution of Botero's marriage) and the unresolved impact of Abstract Expressionism. When several were shown at Gres Gallery in October 1960, collectors who had responded favorably to Botero's earlier, brighter work were perplexed. "Only a few Washington collectors came to understand and eventually purchase a Niño," Beatrice Perry notes.[18]

Abstract Expressionism still dominated the art scene in New York when Botero moved there following the Gres Gallery show. He rented a loft at the corner of MacDougal and Third streets in Greenwich Village. Always a prodigious producer, he recalls that:
In New York, I was working like crazy. I was a compulsive worker there. I just couldn't stop. It was like an obsession, a sickness.

After I was married [to Cecilia Zambrano], for instance, we would go to the country and stay for a month. I would get up in the morning and right away I would start painting. After dinner I would go into the studio to look and make sketches. At night I couldn't sleep, the paintings would keep dancing in my mind.

Through Ospina, Botero got to know Willem de Kooning and met Franz Kline, Mark Rothko, and other Abstract Expressionists. He had only slightly closer contact with the artists of his own generation, such as Red Grooms and Peter Forakis, who were exhibiting in the cooperative galleries on Tenth Street. Naturally, he also knew many of the artists from South and Central America who faced, as he did, special discrimination in a city that dismissed anyone with a Spanish accent as "Puerto Rican." "It was a handicap," he asserts, "to be a Latin American in New York."

Botero's foreign background no doubt exacerbated the art world's harsh reaction to the distorted realism of his style. Grace Hartigan, who had moved from New York to Baltimore, has commented: *I thought he had a unique vision, and that he was quite brave in preserving it and being solitary. . . . This showed great strength. He was a remarkable young talent. . . . The abstract artists in New York hated his work. I defended him, just as I did Francis Bacon.*[19]
Botero's own memories are vivid:

At that moment, the School of New York was very heavy on you. If you weren't Abstract Expressionist, you were not a painter, you didn't exist.

Everyone was against me. I didn't have any friends, the whole atmosphere was hostile. And, of course, when you are struggling so hard against the whole thing, you don't have any strength to do your own work. The more you feel an audience behind you, the more you feel reassured, the more you do things that are bold. When you have everyone against you, you are working in empty space.

Thus, while *Camera degli Sposi (Homage to Mantegna) I,* with its strong colors and bold composition, was the work of a confident artist, the second version of this painting, done in 1961 [13], was full of self-doubt. In the later canvas, Botero was flirting with the loose brushwork of the Action Painters, an approach basically antithetical to his style; he had seen canvases by Hartigan and Appel at the Gres Gallery and was now absorbing the influence of de Kooning and Kline. One positive result of his encounter with the Abstract Expressionists was the adoption of their large scale: *Camera degli Sposi (Homage to Mantegna) II* was one-third larger than the first version.

If Botero's paintings were unresolved, they were obviously the work of a talented eclectic. Within a year of his arrival, he attracted a number of enthusiastic collec-

tors. Museum of Modern Art Curator Dorothy C. Miller visited his studio, and as a result, the Museum of Modern Art purchased *Mona Lisa, Age Twelve,* 1959 [12], displaying it prominently in the 1961 *New Acquisitions* exhibition. "Who can look at this disturbing work without taking sides?" queried Alfred H. Barr, Jr., in the brief introduction to the exhibition checklist.[20]

Botero's New York gallery debut took place in November 1962 at The Contemporaries on Madison Avenue. With his work in a transitional phase and only a month's lead time for preparations, the omens were less than promising; he is still bitter over the ensuing debacle: "I was treated in the most horrible way. I never saw criticism so nasty, so personal. They called my paintings caricatures." A dealer who had reserved a number of works canceled when the uniformly negative reviews appeared. Nothing was sold.

Although "for a time, I was painting walls, literally," the thirty-year-old Colombian remained determined as well as prolific. Four years later *Time* recognized his efforts with a celebratory article on his first United States museum exhibition, at the Milwaukee Art Center.[21] The twenty-four recent works, half on loan from private collections, provided evidence of Botero's emergence from a period of tentativeness to one of renewed confidence and growing artistic maturity. As rotund as the apples in his still lifes, the placid heads of his people rest on bodies of equal stolidity. They seem to have a mindless innocence, yet the artist enlivens them with his own gentle wit. The subjects—such as *Madonna and Child* [5]; *The Rich Children* [59]; and *The Supper* [7]—were not new to his repertoire. Even *Our Lady of New York* [6], his only work to suggest a non-Colombian locale, reverts completely in imagery and color to Spanish Colonial prototypes. "I was in New York thirteen

years and never did any subject matter that had to do with America. To paint Washington crossing the Delaware—it never crossed my mind."

The paintings on view in Milwaukee belong to what can be characterized as Botero's classical phase. These and other canvases of the mid-1960s have a new monumentality and plasticity as well as more subtle tonalities. In his unique fashion, Botero was finally achieving what he prized most highly in Piero, the ability to give form and color equal importance.

Life would probably have been easier for Botero had he moved to Europe in 1960. But for an artist then, New York was both Mecca and battleground. So, until 1973, the artist considered the city his principal home. There was the property on Stephen's Hand Pass Road in Easthampton, Long Island, where he had built a house and studio in 1964; the dirty, noisy studio with high ceilings in space rented from a shoemaker at 214 West Fourteenth Street; and the living quarters at various addresses around Greenwich Village.

When Botero traveled to Germany in 1966 for the opening of his solo show at the Staatliche Kunsthalle in Baden-Baden, he immediately felt the special sympathy

fig. 5
Martial Raysse (French, b. 1936)
Made in Japan, 1964
Synthetic polymer and collage on photomechanical reproduction mounted on canvas, 129.5 x 266.7 (51 x 105)
Hirshhorn Museum and Sculpture Garden, Smithsonian Institution, Washington, D.C.

that Europeans have for his work. There are several reasons for this enthusiasm. First, in his response to Western art traditions, Botero is closer in spirit to the Nouveaux Réalistes on the Continent, such as Martial Raysse (fig. 5), than to their counterparts in England or the United States. Second, he came to Europe via New York where, as a foreign artist, he had not only held his artistic ground, but had seen his work acquired by the Museum of Modern Art and the Solomon R. Guggenheim Museum. Third, his career had paralleled those of the New York Pop artists, whose works were also being avidly sought by German and Belgian collectors. Finally, he is Latin American and, in contrast to the discrimination he had encountered in New York:

I find it so pleasant to live in Europe. In Paris they believe that the strong art forms of the future, the very near future, will come from Latin America; they believe there is an energy. As a matter of fact, a lot of Latin American artists living there are super-accepted: Matta, Lam, Soto, . . .

Thus, in the early '70s, Botero joined the European avant-garde which, according to critic Lucy Lippard, "is a migratory group, with Paris the centre and increasingly large numbers shuttling between there, London and New York. . . . The exhibition network is widespread, and a successful artist may show in Paris, Milan, Amsterdam, Düsseldorf, and Copenhagen within a year's time."[22]

After the initial trip to Baden-Baden, Botero generally scheduled his European journeys to coincide with his increasingly

frequent solo exhibitions. He rented an apartment in Paris on the boulevard du Palais in 1971 and, after a two-year interval of dual residency, moved there permanently. In 1971 he also established a studio in Bogotá and, a year later, purchased a house in Cajicá, north of that city, where he returns for a month each summer.

Whether created in Easthampton, Manhattan, Paris, Cajicá, or Bogotá, Botero's paintings from the migratory period between 1966 and 1975 can be distinguished from those of his earlier classical phase. Although the technically adroit artist returned repeatedly to favorite themes and images, changes could be observed in his approach to still lifes as well as to the Old Masters. In its rendering of hard, glittering metal armor, *Alof de Vignancourt (after Caravaggio),* 1974 [19], is Botero's tour de force. Unlike *Los Arnolfini 3,* 1964 [16], in which Giovanni and his bride are pushed toward the picture plane and most of Jan van Eyck's background details disappear, the Caravaggio copy closely follows the composition of its prototype. Moreover, in contrast to his phlegmatic, blocklike Arnolfini couple, Botero's great Master of the Knights Hospitallers, although perhaps more Colombian or German than French, remains a formidable military commander.

Cézanne's apples, Botero says succinctly, "prove that you can do it with a little or a lot." His own *Apples (Fruit)* of 1964 [25] and other still lifes from the early '60s are sensuous, sculptural, and preeminently Latin. In contrast, the *Fruit Basket* of 1972 [31] is overladen, and the arm reaching toward it threatens total upheaval; a year later its melons, grapes, bananas, and pears are transformed into the corpses, flags, and booty of *War* [54]. There is in the works of this migratory period a loss of innocence.

The exceptions, of course, are the cherubic images of Pedro, Botero's New York-born son. Pedrito was recorded in all stages of confident babyhood, asleep, on a hobbyhorse, posing with a toy monkey [63]. Then, in April 1974, the family was involved in an automobile accident as they were returning to Paris from Seville, and Pedro was killed. "Pedrito Botero: Un cuadro inconcluso" ("Pedrito Botero: An Unfinished Painting") headlined Bogotá's *El Espectador.* [23] Although the drawing *Painter of Still Lifes,* 1975 [64], is not, as previously believed, a self-portrait, "Pedro is there. I added him at the last moment." The Sala Pedro Botero, a permanent exhibition of sixteen paintings and drawings donated by the artist, was inaugurated in 1977 in the principal art museum of Medellín.

During the period from 1975 to 1977 Botero's Paris studio was transformed into a sculptor's atelier (fig. 6). Years earlier he had sketched from plaster casts in the Prado and had spent about two weeks in a sculpture class at the Accademia San Marco which, like other courses there, provided little technical training. While teaching in Bogotá's Escuela de Bellas Artes in 1958–60, he became interested in working with clay when Pedro Moreno, a sculpture

fig. 6
Botero in his studio, Paris, 1979

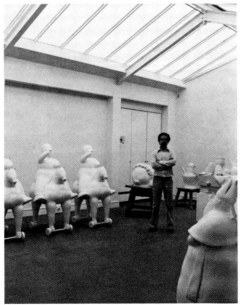

COURTESY OF THE ARTIST

student, asked him to sit for a portrait. About 1964 in New York, using a tedious method he had invented for working with acrylic paste, Botero produced his earliest surviving sculptures, a pair of small painted heads [see 4]. There was an obvious reason for his experimentation: until the 1970s he could not afford the traditional procedure of having works cast at a foundry. In 1973, he produced four pieces that were cast in bronze or epoxy resin. "All my life I have felt that I had something to say in sculpture," he told André Parinaud in 1977. "Then, one day, it was necessary to make a decision. To make sculpture I have had to stop painting for several years." [24]

Of the twenty-five sculptures modeled during this period, only *Pedro on a Horse,* 1977 [65], Botero says, in any way reproduced a painting. "While I did my sketch for the sculpture, I did it in profile, the animal, the figure, and when I was through and I looked at it in front, it was the same painting. But I was not concerned by this."

His sculptures are unlike those of Magritte or de Chirico, Botero emphatically declares. Whereas technicians worked from paintings such as the Belgian Surrealist's *Delusions of Grandeur,* 1948, to produce the three-dimensional version, dated 1967, all of his own pieces begin with new sketches. For him, "a sketch is the sparkle of a conviction."

The point of departure for a work is always the sketch. Ninety percent of the time the solution to a painting is in the sketch. In a sculpture, it's the same thing, but the sketch is more complex.

I do a lot of sketching. Let's say I have a subject in mind. I kind of sit there and make a sketch and say, "How about a figure there?" and then I make a sketch with the figure there, then without the first element. I let my imagination run like this for two or three days. I do hundreds of

sketches, sketch, sketch, sketch. . . .

I must have five thousand sketches in my studio, some of them very, very finished; perhaps I had been working two hours. Or I work five minutes. Then for two or three months I don't do any sketches. But I come back all the time to look at them.

The tail of a little archaic Greek sculpture of a mermaid, a tiny one in a museum somewhere in Italy, it has a tremendous plasticity; I go back to my hotel room and I make a sketch.

As a sculptor, Botero belongs to the post-Rodin figurative tradition of such artists as Henri Matisse, Elie Nadelman, Gaston Lachaise, and Henry Moore. When translated into three rather than two dimensions, his images appear more familiar and less overtly Latin American.

Just as Moore's reclining figures reflect a study of Pre-Columbian works such as

the Chac Mool from Chichén Itzá in the Yucatán, Botero's polychromed *Little Whore* [46] can trace her ancestry to painted Tanagra terra cottas as well as to Colombian folk art. Her more recent relatives may include Nadelman's painted wood figures (see fig. 7), which Botero could have seen at the Museum of Modern Art. In their monumental voluptuousness and subdued eroticism, Botero's sculptures such as *Eve* [48] are closest of all to those of Lachaise (see fig. 8), and Botero's revealing comment about himself could apply equally to Lachaise: "To be mad and to have a style are the same thing. A style is the product of an obsession; it is unhealthy."

Botero's sculptures dating from 1976 and 1977 have all been cast in editions of six at the Tesconi or Mariani foundries in Pietrasanta, Italy, or at Susse or Haligon in Paris. They were first exhibited as a group at the Paris art fair FIAC in 1977. Until eight days before the show opened, Botero had not seen the works together in bronze or resin. "I was working in plaster without knowing exactly how they would be looking from the foundry. Now I know, and I have a lot of ideas." Having experimented with two different patinas on the final casts of the bronze *Bird on a Column* [33], he is thinking about using two kinds of marble in one piece and about combining marble and bronze. "Every day you get excited about something new."

An artist, says Botero, paraphrasing Picasso, is a collector of all the art of the past. "In each of my works, I can see where the idea came from." In his home in Paris he has surrounded himself with ob-

jects that give pleasure but are never used directly in his own work: a painting and a watercolor by Matisse; Rodin's *Iris, Messenger of the Gods;* works by fellow artists such as Balthus and Ipoustéguy; several Spanish Colonial paintings; and what he considers his special treasure, a group of Pre-Columbian sculptures.

After the period of preoccupation with sculpture, of "going back to basics," huge unstretched canvases again cover the walls of his Paris studio, which in a former era housed the Académie Julian. Once more, Botero is painting at a prodigious rate. Familiar subjects like *Los Arnolfini* are repeated; new studies after Old Masters such as Ingres's *Mlle. Rivière* make their debuts. In a series of paintings from the spring of 1979, including *The Musicians* [66], there is a new monumentality of forms that reflects his experiences as a sculptor while, at the same time, recalling the Cubist canvases of Fernand Léger. In

fig. 7
Elie Nadelman (American, b. Russian Poland, 1882–1946)
Circus Girl, c. 1919
Gessoed mahogany, 79.2 x 31 x 16.1
(31¼ x 12¼ x 6⅜)
Hirshhorn Museum and Sculpture Garden, Smithsonian Institution, Washington, D.C.

fig. 8
Gaston Lachaise (American, b. France, 1882–1935)
Standing Woman (Heroic Woman), 1932
Bronze, 224.8 x 112.7 x 62.7 (88½ x 44⅜ x 24⅝)
The Brooklyn Museum, New York
Frank C. Benson, A. Augustus Healy, Alfred T. White, and Museum Collection Funds

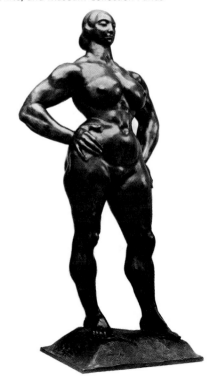

Still Life in Front of a Window [35] and *Landscape with Trees* [34] there is a simplification of composition and, in the latter, a renewed touch of whimsy.

In the course of three decades of hard, disciplined effort, Botero has created a formidable oeuvre: more than one thousand paintings, thirty-two recorded sculptures,[25] a large fresco in Medellín (see Chronology), and at least five or six thousand drawings in pencil, ink, charcoal, sanguine, pastel, or watercolor.

One of the most important artists to emerge from South America since World War II, Botero has an ardent following on three continents. In Colombia, he and writer García Márquez dominate the cultural scene. Always a controversial figure, the articulate, self-critical artist has secured his independence and is disinclined to speculate about the future:

The act of painting is such a fantastic feeling; it is the greatest joy. It takes years before your hand and your mind are communicating; now I don't lose control at all.

You have a very clear, precise idea about the central problem, and in every painting, you get closer. Painting is like tuning an instrument; in the process of tuning there is an evolution.

Notes

1. Dr. Wibke von Bonin, "An Interview with Fernando Botero," in *Fernando Botero,* exhibition catalog (New York: Marlborough Gallery, 1972), pp. 9–10 (interview reproduced from *Botero: An Island in Manhattan,* 1969, a film made for German television by Hammermill Productions).

2. For an analysis of the stages of development of Latin America's artists, see Thomas M. Messer, "Latin America: Esso Salon of Young Artists," *Art in America* 53 (October–November 1965): 121.

3. Von Bonin, "Interview," p. 11.

4. Jean Franco, *The Modern Culture of Latin America* (New York: Praeger, 1967), p. 253.

5. Marta Traba, "Colombia Year Zero," *Art International* 9 (June 1965): 16.

6. Carlos Jiménez Gómez is author of several books, including *Retrato de Familia* (Bogotá: Editorial Visión Fotolitografía, 1975). Poet Gonzalo Arango, a leader of Colombia's avant-garde, died in an automobile accident in 1976. Jaime Piedrahita was an opposition candidate for president in the Colombian elections of 1978.

7. Fernando Botero, interviewed by the author. With Sareen R. Gerson, Hirshhorn Museum and Sculpture Garden, February 8–9, 1979; with Linda Cabe, Hirshhorn Museum and Sculpture Garden, July 9–20, 1979; with Linda Cabe, Marlborough Gallery, New York, July 27, 1979. All uncited statements by the artist are taken from the above.

8. Botero, "Picasso y la inconformidad en el arte," *El Colombiano* (Medellín), Supplement, July 17, 1949, p. 3. Translated by Luis Lastra.

9. Botero, "Anatomía de una locura," *El Colombiano,* Supplement, August 7, 1949, p. 4. In this article, Botero commented that "In 1936 began the emigration of the Surrealist 'troupe' to North America; Surrealism became the topic of the day." See Cynthia Jaffee McCabe, *The Golden Door: Artist-Immigrants of America, 1876-1976,* exhibition catalog (Washington, D.C.: Smithsonian Institution Press for Hirshhorn Museum and Sculpture Garden, 1976), pp. 31–38, 80–89.

10. The evening of his arrival, June 16, 1953, shouting Frenchmen thronged the streets to protest the execution of Julius and Ethel Rosenberg in the United States.

11. Fattori's advice to his students might have been useful to the studio's newest occupant: "Please create that art in which you believe, . . . But to every one of you to whom I have always preached: *be yourself*—don't run after the first comer who paints blue shadows, and light the color of orange flowers" (Giovanni Fattori, "Letter to a Group of Pupils," *Realism and Tradition in Art, 1848-1900: Sources and Documents,* ed. Linda Nochlin [Englewood Cliffs, N.J.: Prentice-Hall, 1966], p. 146).

12. Leslie Judd Portner, "Art in Washington," *Washington Post and Times Herald,* April 28, 1957, sec. F, p. 7.

13. "Preludios de salón," *Semana* (Bogotá), September 9–15, 1958, pp. 42–43.

14. Beatrice Perry, interview with the author, Hirshhorn Museum and Sculpture Garden, July 9, 1979. Eight days before Botero arrived for the show's opening, ownership of the Gres passed to Perry and a group of other Washingtonians.

15. Gabriel García Márquez, "La siesta del martes," *El Tiempo* (Bogotá), Lecturas Dominicales, January 24, 1960, p. 1.

16. Jorge Zalamea, "Botero," *Cromos* (Bogotá), no. 2215, November 23, 1959.

17. Reprinted in "Mona Lisa Age Twelve by Fernando Botero 1959," *Cosmopolitan* 153 (December 1963): 94.

18. Perry, interview with the author.

19. Grace Hartigan, interview with the author and Sareen R. Gerson, Hartigan studio, Baltimore, March 28, 1979.

20. Alfred H. Barr, Jr., *Recent Acquisitions: Painting and Sculpture* (New York: Museum of Modern Art, 1961), p. 1. Botero's own comments quoted previously were used as copy for the wall label accompanying the painting.

21. "Piñatas in Oil," *Time* 88 (December 30, 1966): 26.

22. Lucy R. Lippard, *Pop Art* (New York and Toronto: Oxford University Press, 1966), p. 185.

23. Inés de Montaña, "Pedrito Botero: Un cuadro inconcluso," *El Espectador,* April 20, 1974, Sec. A, p. 14.

24. André Parinaud, "L' aventure de l'art moderne: Botero par Botero," *Galerie Jardin des Arts: Revue Mensuelle* (Paris), no. 166 (February 1977), p. 13.

25. Ursula Bode, *Fernando Botero: Das plastische Werk* (Hanover: Galerie Brusberg, 1978).

Chronology

Linda Cabe

1932
April 19—Fernando Botero Angulo born in Medellín, in the department of Antioquia, Colombia. His father, David Botero (1895–1936), traveled throughout Antioquia as a salesman. His mother, Flora Angulo de Botero (1898–1972), like his father, came from a small town in Antioquia. Fernando is the second of three children; his brothers are Juan David (born 1928) and Rodrigo (born 1936).

1938–43
Attends Ateneo Antioqueño, a primary school in Medellín.

1944–49
Attends Bolivariano, a Jesuit secondary school in Medellín.

1948
Works as an illustrator (until 1951) for the Sunday literary supplement of *El Colombiano,* the major Medellín newspaper. Two watercolors included in the *Exposi-* *ción de pintores antioqueños,* Medellín—his first group show. These works, *The Dead Child* and *Alcohol,* later appear in his first solo show, at the Galerías de Arte Foto-Estudio Leo Matiz, Bogotá (1951).

1949
July—expelled from Bolivariano for writing an article on Picasso and nonconformity for *El Colombiano.* July–November— finishes school year at the Liceo San José in the nearby town of Marinilla.

1949–50
Makes first trip out of Antioquia, spending his vacation at Barranquilla on the Caribbean coast.

1950
Attends the Liceo de la Universidad de Antioquia, Medellín. November—receives baccalaureate. Works for two months as

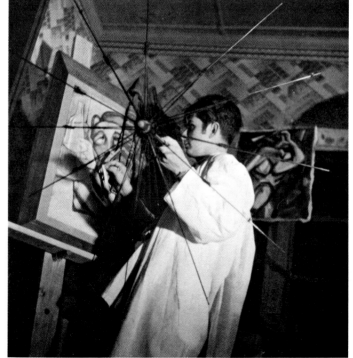

Botero "playing surrealismo" with some of his early paintings in Medellín, 1948

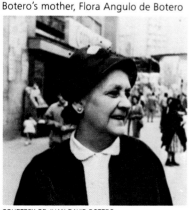

Botero's mother, Flora Angulo de Botero

set designer for touring Spanish theater group, Compañia Lope de Vega.

1951

January—moves to Bogotá. June—first solo show, of twenty-five watercolors, gouaches, drawings, and oils, at the Galerías de Arte Foto-Estudio Leo Matiz. August—moves to Tolú on the coast of the Gulf of Morrosquillo; paints at Coveñas and the islands of San Bernardo, as well as Tolú.

1952

March—returns to Bogotá. May—second solo show, at the Galerías de Arte de Leo Matiz, of works from Tolú and the surrounding area. August—awarded second prize in the *IX salón anual de artistas colombianos,* Biblioteca Nacional, Bogotá, for *In Front of the Sea* (fig. 2, p. 12). *Botero,* a signed portfolio of twenty black-and-white reproductions, with an introduction by Walter Engel, is published in an edition of 350. Sails for Europe. After a brief stay in Barcelona, moves to Madrid. Studies at the Real Academia de Bellas Artes de San Fernando and the Museo del Prado, where he copies paintings by Goya and Velázquez, among others.

1953

Summer—vacations in Paris; rents an apartment on the place des Vosges. October—moves to Florence; rents a studio at 9 via Panicale. Studies fresco painting at the Accademia San Marco and attends Roberto Longhi's lectures at Università degli Studi di Firenze. Travels throughout northern Italy, visiting every important fresco site.

1954

Spring—much influenced by an exhibition in Florence of the works of Piero della Francesca, Paolo Uccello, Andrea del Castagno, and Domenico Veneziano. Summer—vacations in Paris. Fall—returns to Florence.

1955

March—returns to Bogotá, where his family also lives. May—solo show at the Biblioteca Nacional of forty works (eighteen of which are oil paintings) from Europe,

particularly Florence, is received coolly. August–September—sells tires for a living, does magazine layouts. December—marries Gloria Zea in Bogotá (until 1960).

1956

January—moves to Mexico City. April—first group show in the United States, the *Gulf-Caribbean Art Exhibition,* Museum of Fine Arts, Houston. August 30—son Fernando born in Mexico.

1957

April—travels to New York, then to Washington, D.C., for his first solo show in the U.S., at the Pan American Union, organized by José Gómez-Sicre. May—returns to Bogotá. October—wins second prize for painting in the *X salón anual de artistas colombianos,* Museo Nacional, for *Contrapunto.*

1958

September 20—daughter Lina born in Bogotá. September—*Camera degli Sposi (Homage to Mantegna) I* [10] wins first prize for painting at *XI salón anual de artistas colombianos.* October—first solo

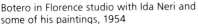

Botero in Florence studio with Ida Neri and some of his paintings, 1954

Botero in Paris, 1954

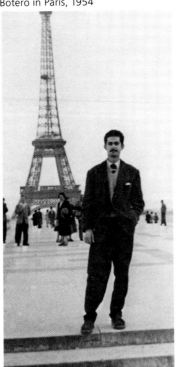

Botero in Bogotá studio with *Camera degli Sposi (Homage to Mantegna) I* [10], 1958

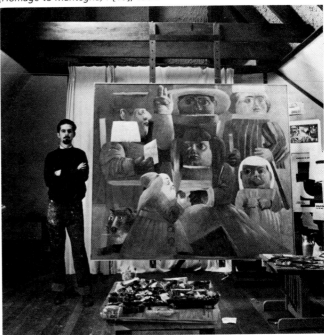

show at the Gres Gallery, 1729 20th St., NW, Washington, D.C., under the directorship of Beatrice Perry. Visits Washington and New York. Included in the Colombian section of the *Guggenheim International Award 1958* exhibition, Solomon R. Guggenheim Museum, New York.

1958–60
Professor of painting at the Escuela de Bellas Artes, Universidad Nacional, Bogotá (for two academic years).

1959
September—represents Colombia at the *V bienal de São Paulo,* Brazil, along with Enrique Grau, Alejandro Obregón, and Eduardo Ramírez Villamizar. September —*Apotheosis of Ramón Hoyos* [56] exhibited *hors concours* at the *XII salón anual de artistas colombianos.*

1960
February—commissioned by Banco Central Hipotecario to paint a mural in its Medellín branch, the only fresco executed by the artist outside of Florence (completed in April). July—serves as Latin American juror for the Miss Universe contest held in Miami. July 18—son Juan Carlos born in Bogotá. August—chosen by art critic Marta Traba to represent Colombia at the *II bienal de México,* along with Obregón, Wiedermann, and Ramírez. The choice causes such an uproar that works by these artists do not go to the Bienal but are exhibited instead at the Biblioteca Luis-Angel Arango, Bogotá, as *25 pinturas y relieves* ("Los pintores auto-excluidos de la II bienal de México"). October—visits Washington for second solo show at Gres Gallery. Moves to New York and rents a loft at the corner of MacDougal and Third streets in Greenwich Village. November— receives the award in the Colombian section of the *Guggenheim International Award 1960* exhibition for *Battle of the Arch-Devil,* 1960.

1961
June—solo show of paintings and twelve illustrations for *El Gran Burundún Burundá ha muerto* by Jorge Zalamea, at Galería de Arte El Callejón, Bogotá. October— following a visit to his studio by Curator Dorothy C. Miller, the Museum of Modern Art, New York, acquires *Mona Lisa, Age Twelve* [12].

1962
November—solo show at The Contemporaries, New York.

1963
February—*Mona Lisa, Age Twelve* displayed at the Museum of Modern Art, to coincide with the exhibition of Leonardo da Vinci's *Mona Lisa* at the Metropolitan Museum of Art. Rents apartment at Tompkins Square, on New York's Lower East Side.

1964
February—marries Cecilia Zambrano in Bogotá (until 1975). July—wins first prize in painting at the *Primer salón Intercol de artistas jóvenes,* Museo de Arte Moderno, Bogotá, for *Apples (Fruit)* [25]. Builds summer house and studio on Stephen's Hand Pass Road in Easthampton, Long Island. Also rents studio at 214 West Fourteenth Street, New York (until 1972).

1966
January—first solo show in Europe, at the Staatliche Kunsthalle, Baden-Baden, Germany (tours to Galerie Buchholz, Munich, in March). September—first solo show at Galerie Brusberg, Hanover, Germany.

Mural in Banco Central Hipotecario in Medellín, 1960

December—*Fernando Botero: Recent Works* at Milwaukee Art Center.

1969
March—solo show at Center for Inter-American Relations, New York. September—first solo show at Galerie Claude Bernard, Paris.

1970
January 19—son Pedro born in New York. March—major solo show of paintings opens at Staatliche Kunsthalle, Baden-Baden, then travels to four other German museums.

1971
September—moves to 30 Fifth Avenue, New York. Rents an apartment on the boulevard du Palais, Paris. Also establishes a studio in Bogotá.

1972
February—first solo show at Marlborough Gallery, New York. March—returns to Paris and rents a studio on rue Monsieur-le-Prince. Buys home in Cajicá, north of Bogotá, where he returns each summer.

1973
Moves to Paris; spends eight months of the year there. November—the Colombian Antituberculosis League issues a stamp illustrating *Pedro in Highchair*.

1974
April 19—Botero is injured and his son Pedro is killed in an automobile accident in Spain.

1976
April—presented with the order "Andrés Bello" by the president of Venezuela in conjunction with a retrospective at the Museo de Arte Contemporáneo de Caracas.

1976–77
Focuses almost exclusively on sculpture.

1977
May—receives the Cruz de Boyacá (grado de oficial) from the government of Antioquia in recognition of his service to Colombia. September—opening of the Sala Pedro Botero at the Museo de Zea de Medellín, a room of sixteen of his works donated by the artist in honor of his late son. October—first solo show of sculpture, at 4e Foire International d'Art Contemporain 1977 [FIAC], Paris, organized by Galerie Claude Bernard.

1978
November—moves studio in Paris to the building on rue du Dragon that had previously housed the Académie Julian.

23

Botero's current studio in Paris

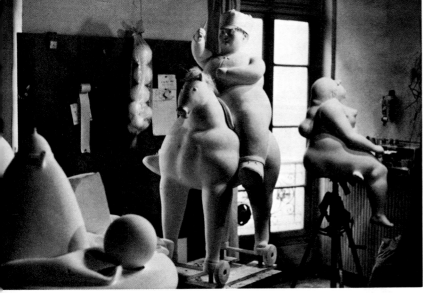
Botero's sculpture studio in Paris, 1977

Color Plates

Color plates are arranged chronologically. Numbers in brackets refer to catalog entries.

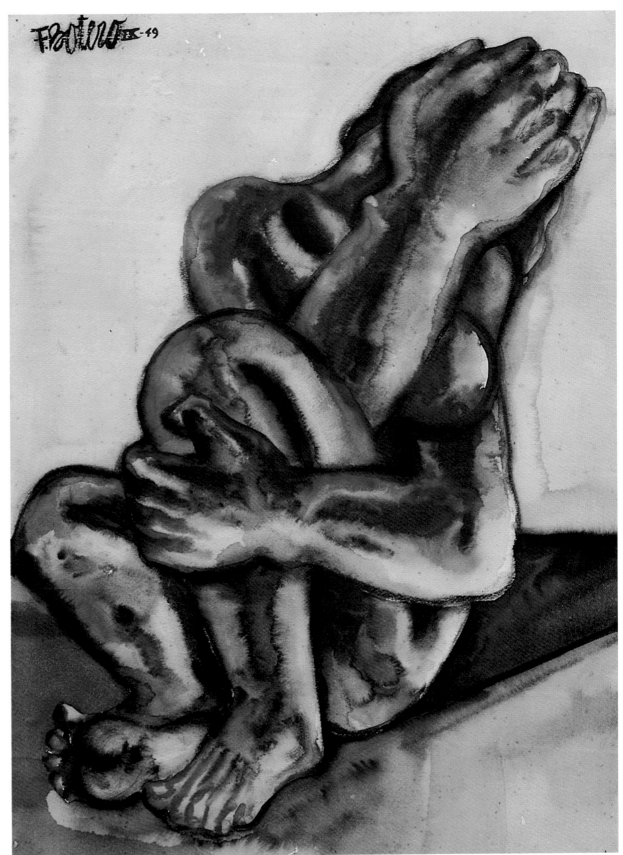

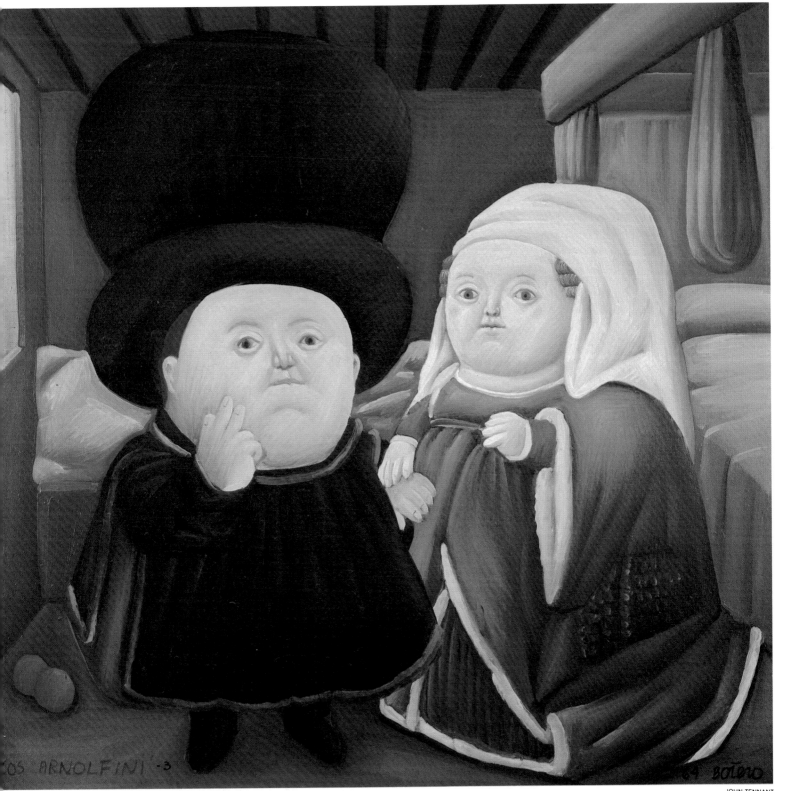

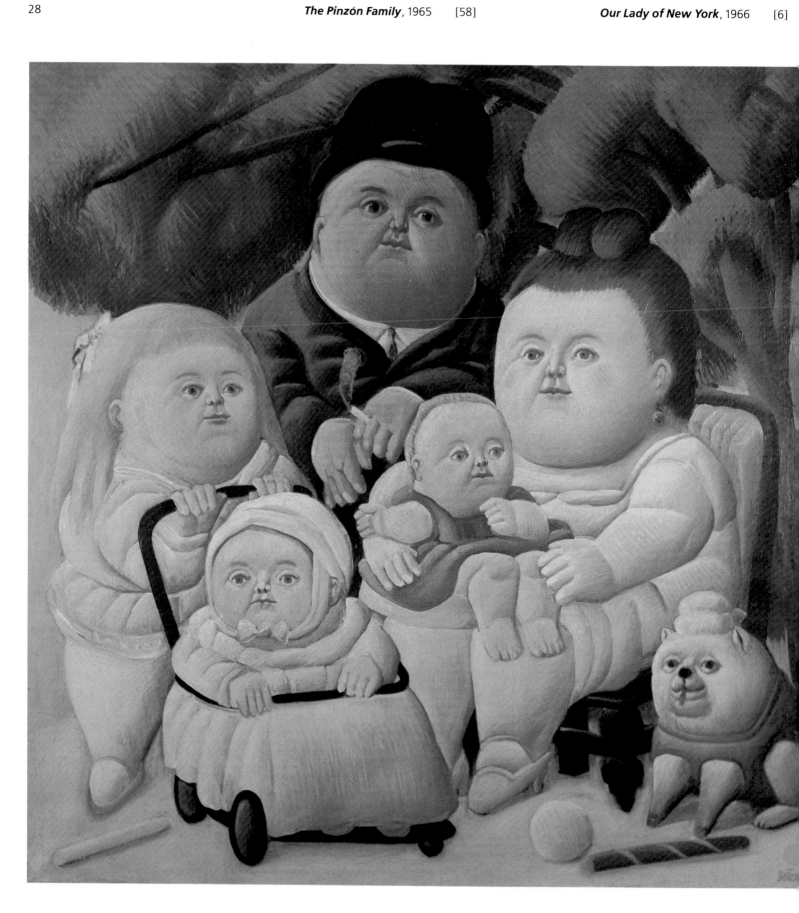

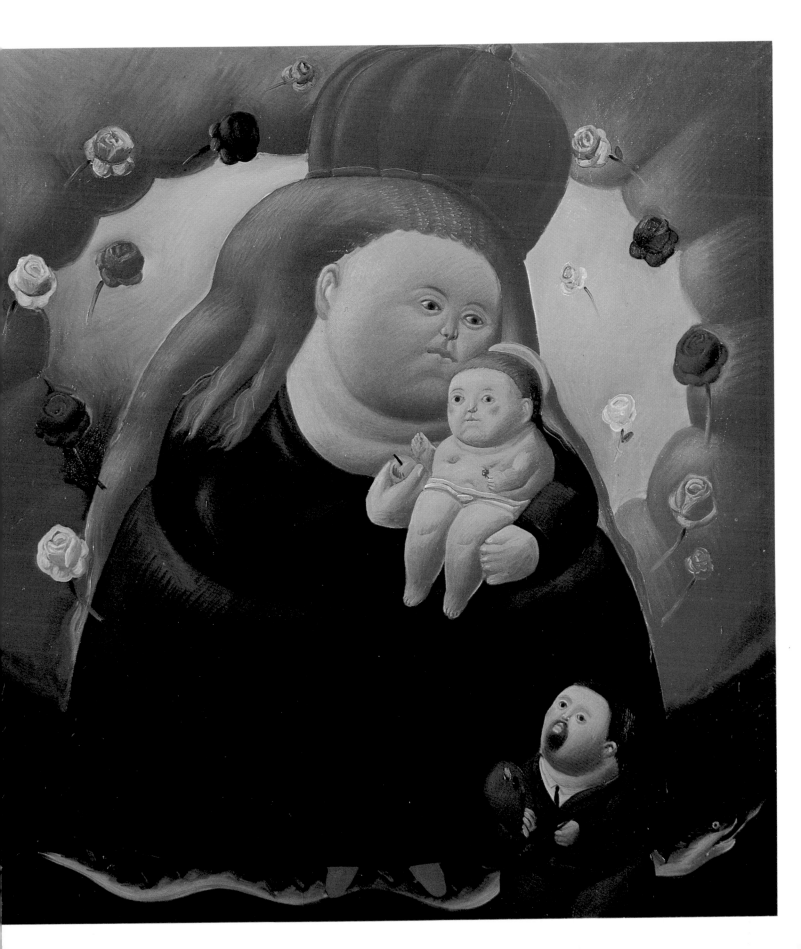

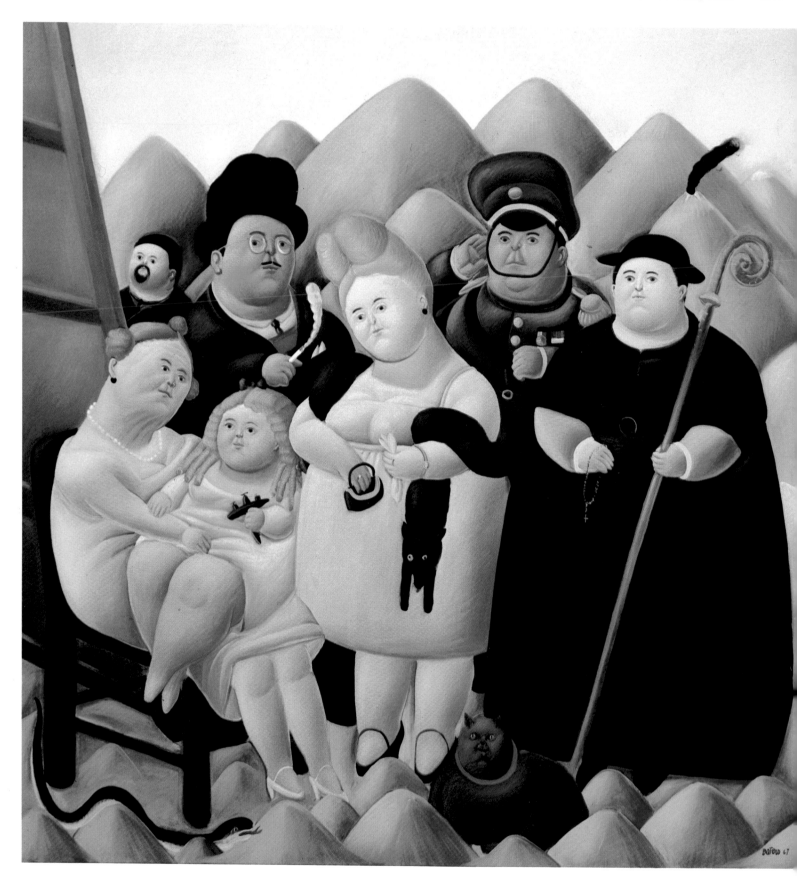

Portrait of Mr. and Mrs. Thomas M. Messer, 1968 [60]

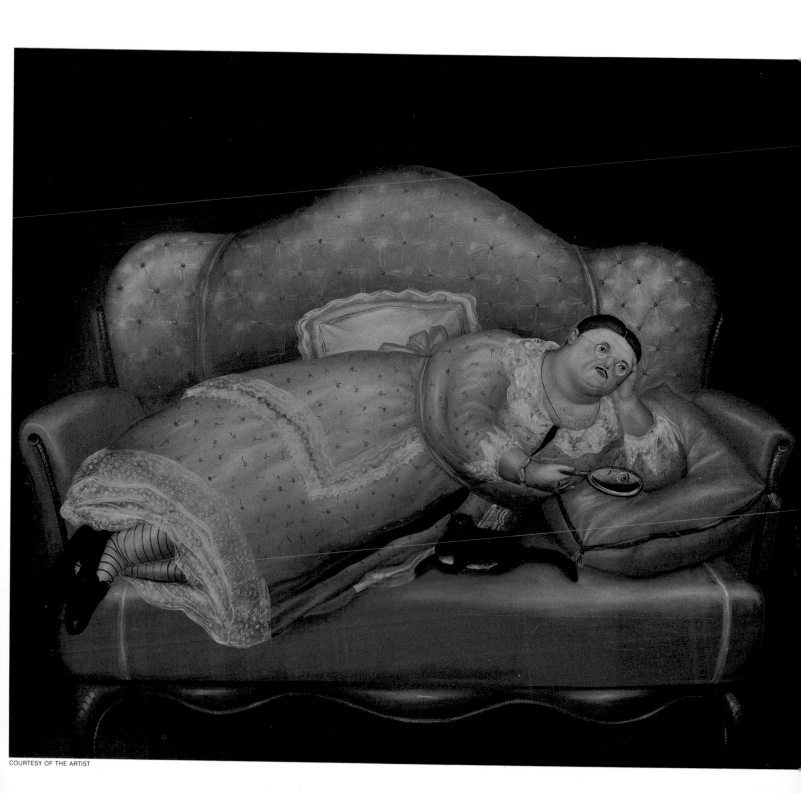

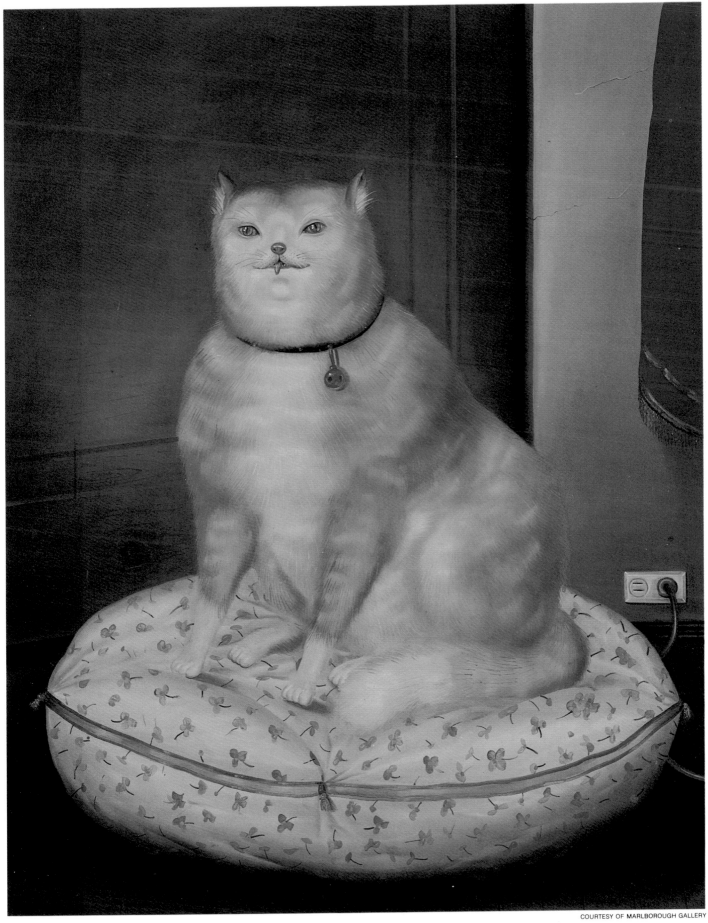

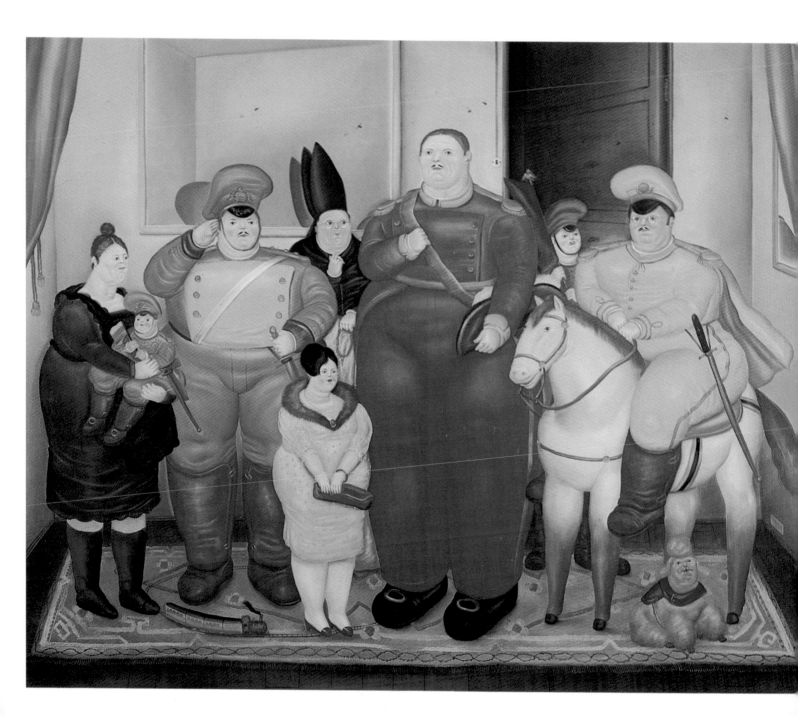

War, 1973 [54]

35

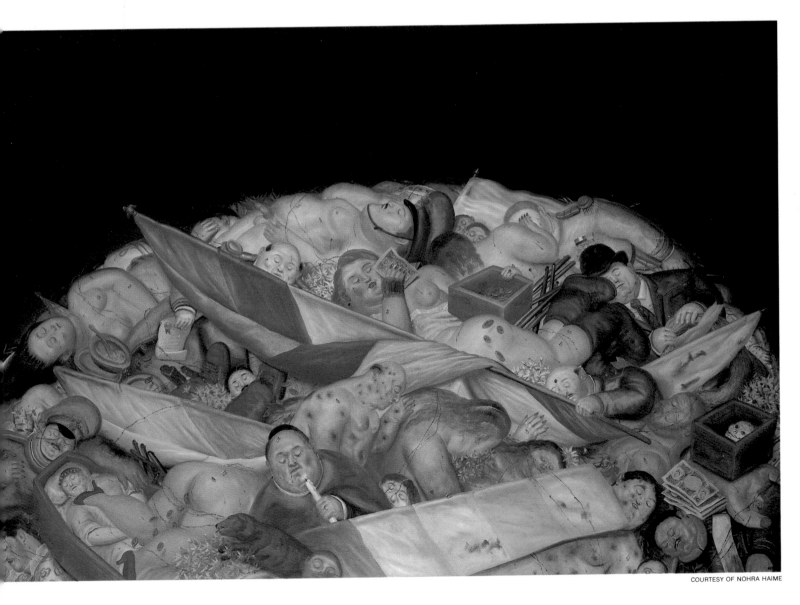

COURTESY OF NOHRA HAIME

Onions, 1974 [32] *Alof de Vignancourt (after Caravaggio)*, 1974 [19]

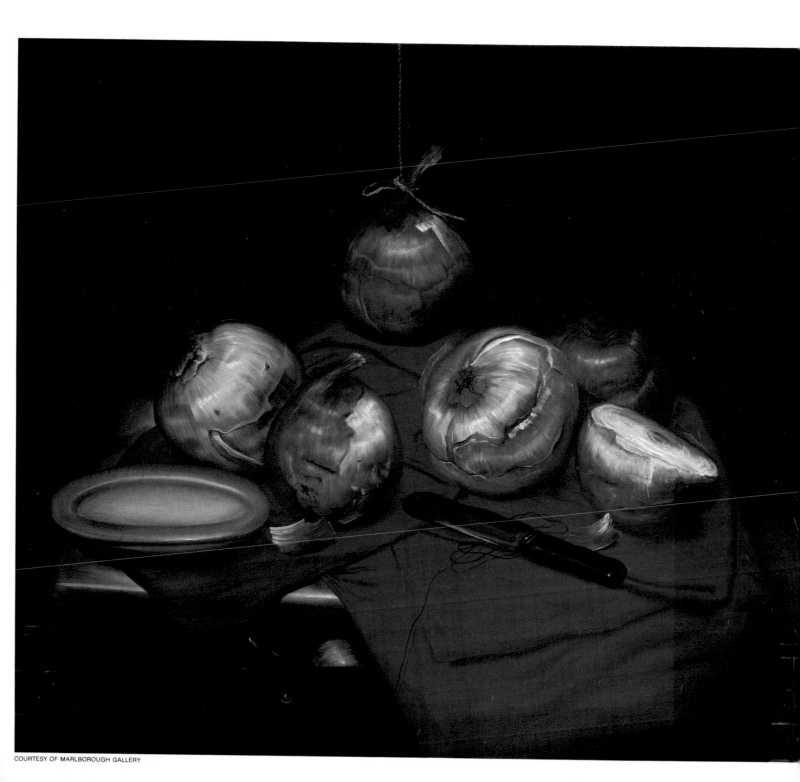

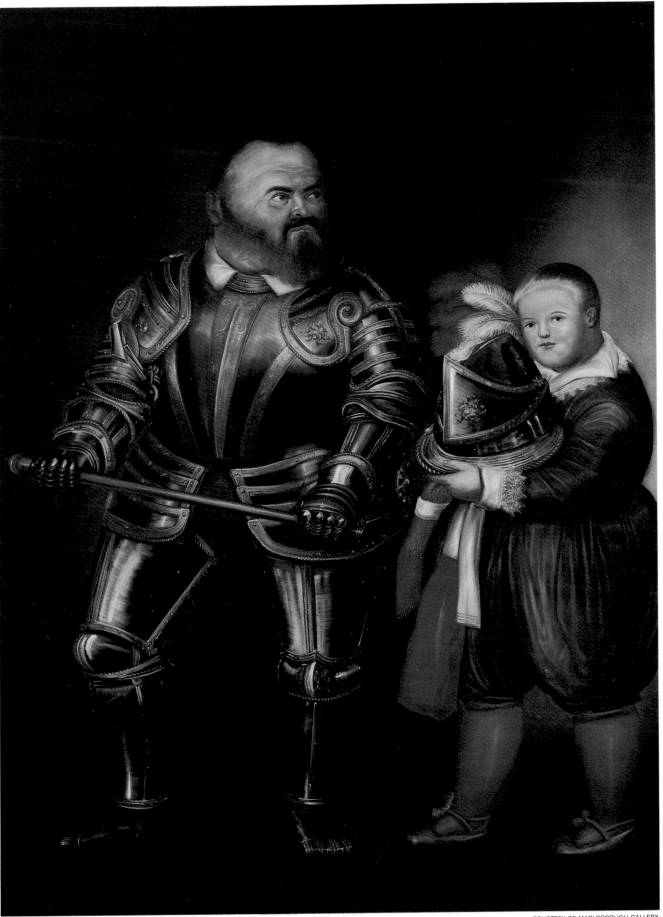

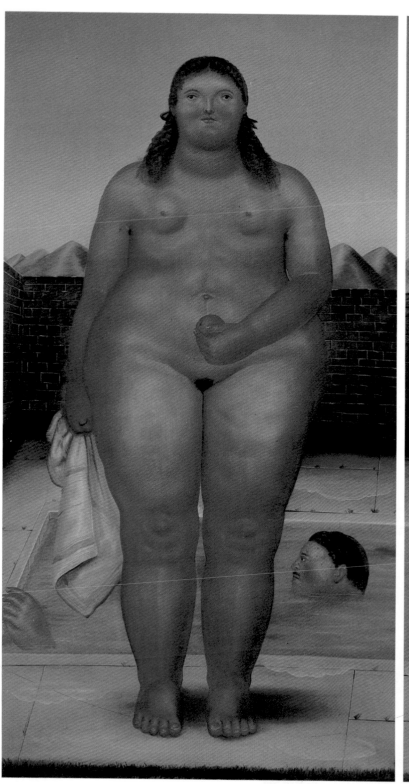
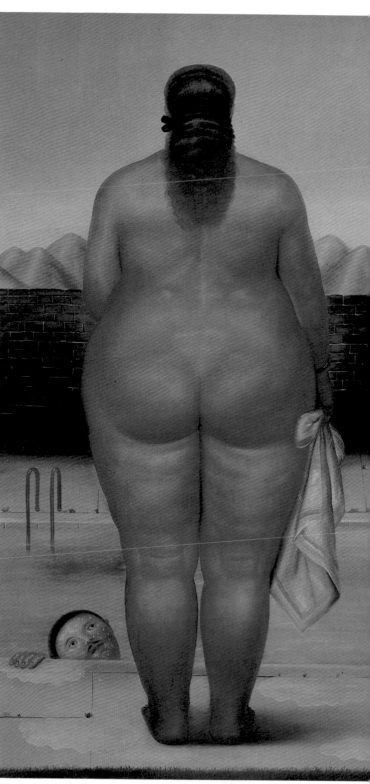

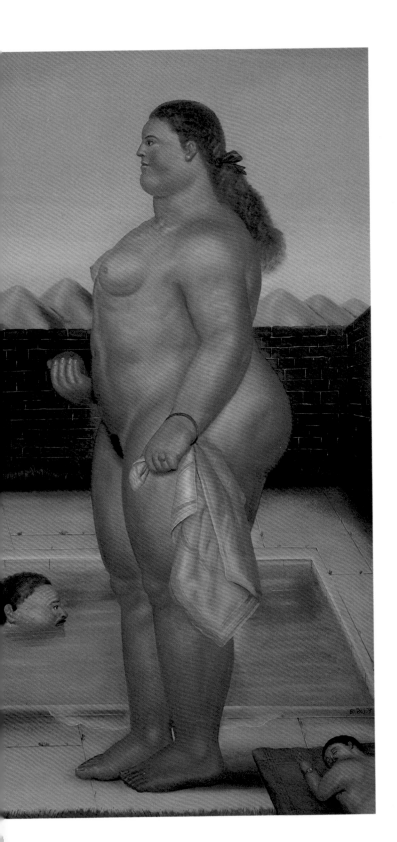

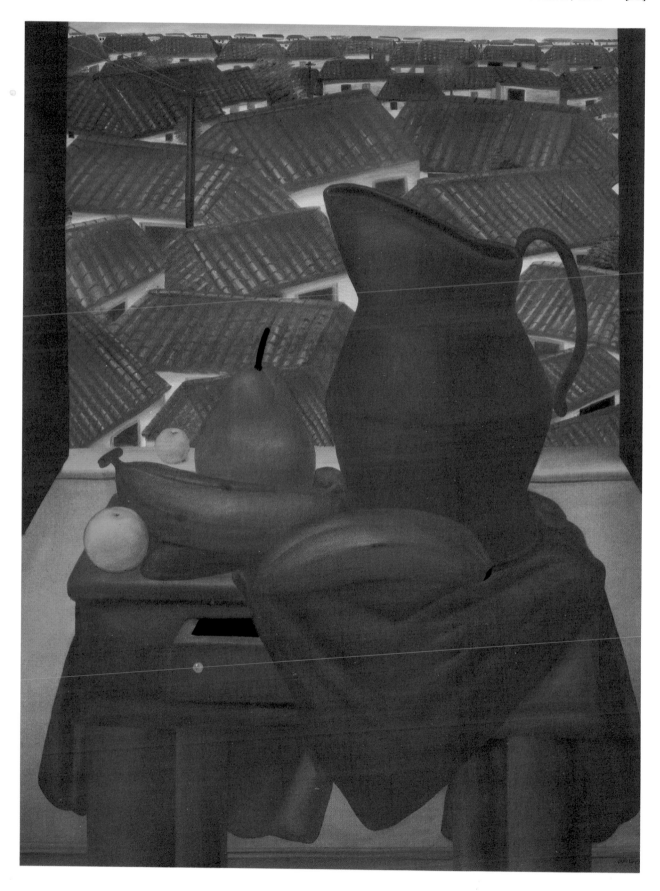

Catalog of the Exhibition

The works are divided into six categories—Religion, Old Masters, Still and Animate Lifes, Nudes and Sexual Mores, Politics, and Real and Imaginary People—which reflect some of the artist's recurring interests. Within each category, the works are arranged chronologically.

Dimensions, as supplied by lenders, are given in centimeters (and inches), height x width x depth. An asterisk by a catalog number indicates that the work will be exhibited in Washington, D.C., only [see 4, 15, 26, 36, 42, 47, and 48]. Although the artist has titled his works in a variety of languages, he has suggested that for the sake of consistency all titles be given here in English. Unless otherwise indicated, all photographs are courtesy of the lenders.

Religion

When asked about his reasons for portraying so many Madonnas and clergymen, the artist replied, "I am not religious, but religion is part of a tradition in art."

1.
The Sleeping Bishop
(The Dozing Archbishop), 1957
Oil on canvas, 24.1 x 88.9 (9½ x 35)
Mr. and Mrs. Miguel Aranguren,
Arlington, Virginia

This work was illustrated on the cover of the
catalog for the artist's first solo show at the
Gres Gallery, Washington, D.C., in 1958.

"I don't believe I have to follow the proportions
of reality. These arbitrary proportions, the feel-
ing of monumentality, are very Italian, very
quattrocento."

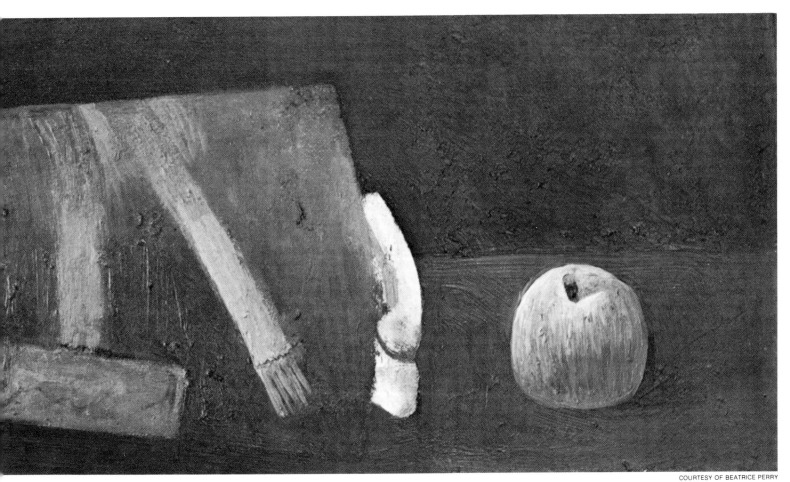

2.
The Miracle of St. Hilarion, 1958–59
Oil on canvas, 40 x 189.9 (15¾ x 74¾)
Mr. and Mrs. Samuel M. Greenbaum,
Washington, D.C.

The early Renaissance predellas he saw in Florence inspired Botero to make a series of paintings dramatizing fictitious episodes in the lives of such figures as St. Hilarion and Pope Honorius III [3].

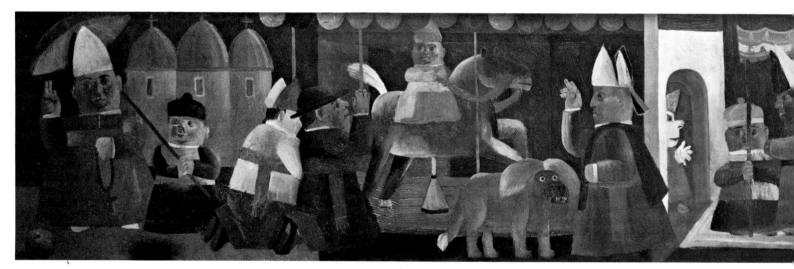

3.

The Life of Honorius III, 1961

45

Oil on canvas, 53.3 x 273.1 (21 x 107½)
Hirshhorn Museum and Sculpture Garden,
Smithsonian Institution, Washington, D.C.

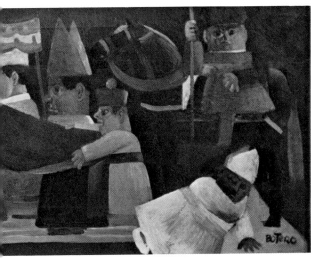

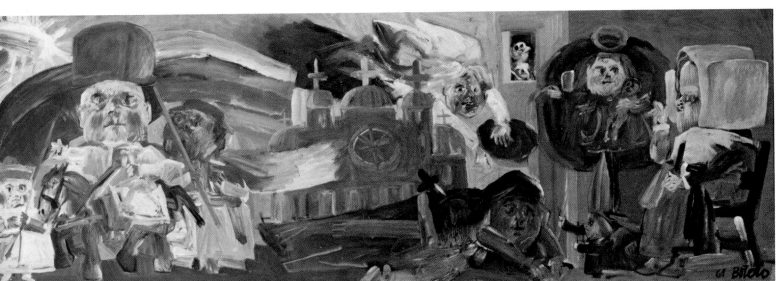

*4.
Little Head (Bishop), 1964
Painted acrylic paste,
30.5 x 24.5 x 16.2 (12 x 9⅝ x 6⅜)
Joachim Jean Aberbach, New York

5.
Madonna and Child, 1965
Oil on canvas, 213.4 x 177.8 (84 x 70)
Beatrice Perry, New York

Botero's Madonnas are in the tradition of
Spanish Colonial icons—virtually the only art he
saw in his youth, in the churches and museums
of Medellín—but are distorted in his own
characteristic style.

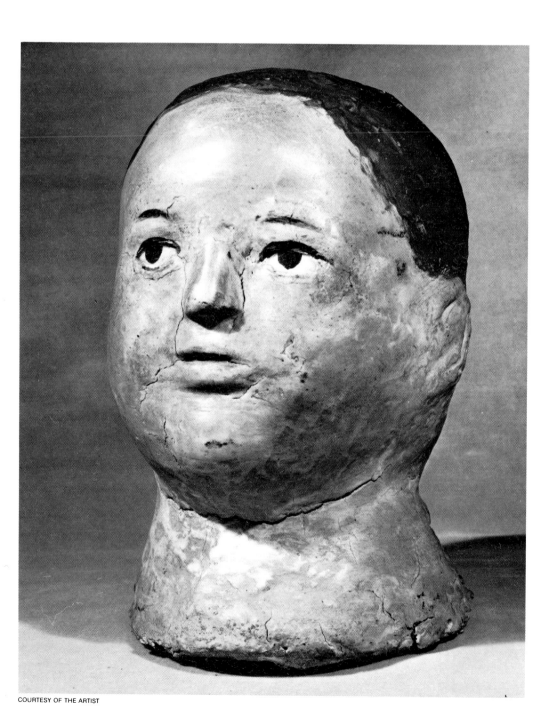

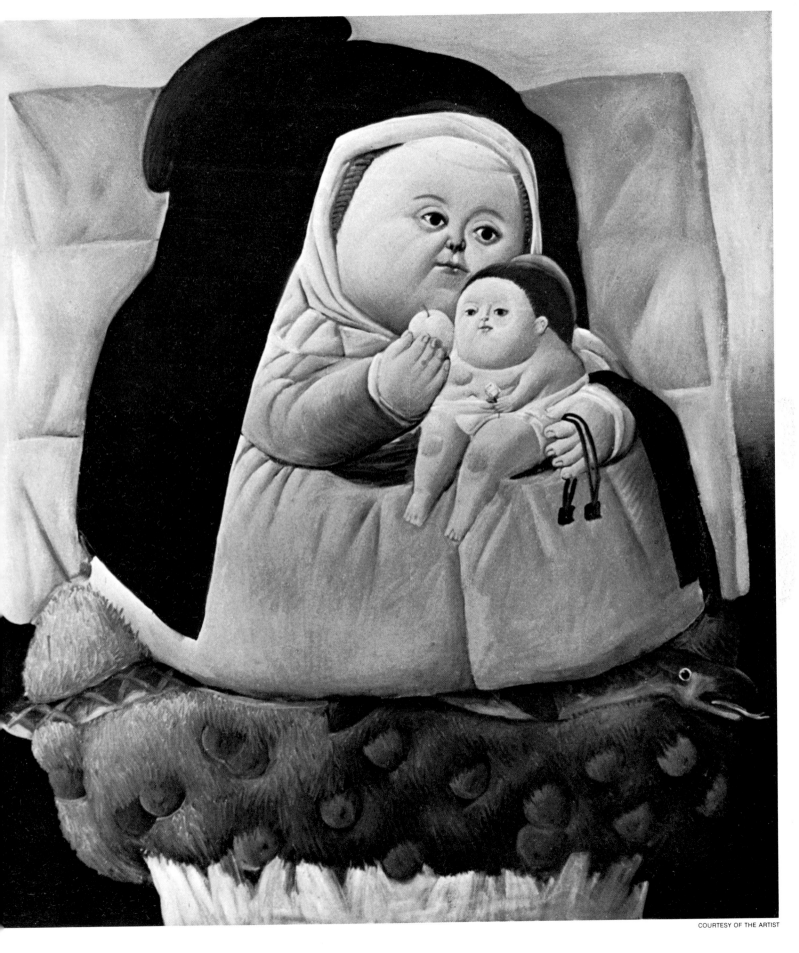

48

6.
Our Lady of New York, 1966
Oil on canvas, 200.7 x 180.3 (79 x 71)
Paul S. Newman
See color plate, p. 29, and back cover

Drawing of *Our Lady of New York*
Collection of Lisa Sumner Newman
(not in exhibition)

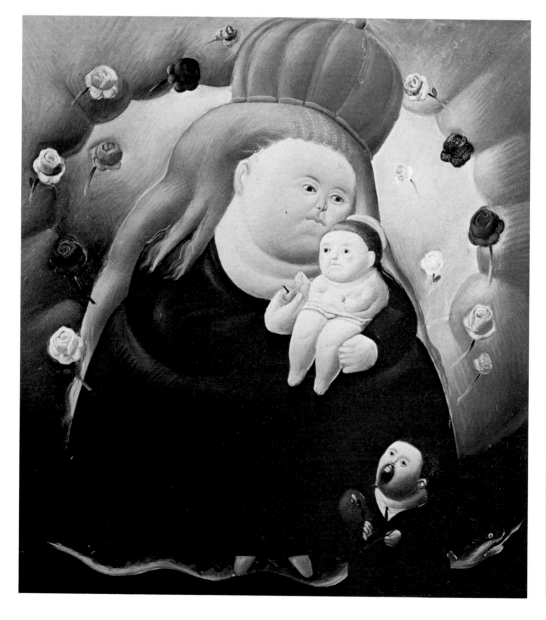

7.
The Supper, 1966
Oil on canvas, 198.1 x 193 (78 x 76)
Milwaukee Art Center Collection
Gift of Gimbels Department Stores

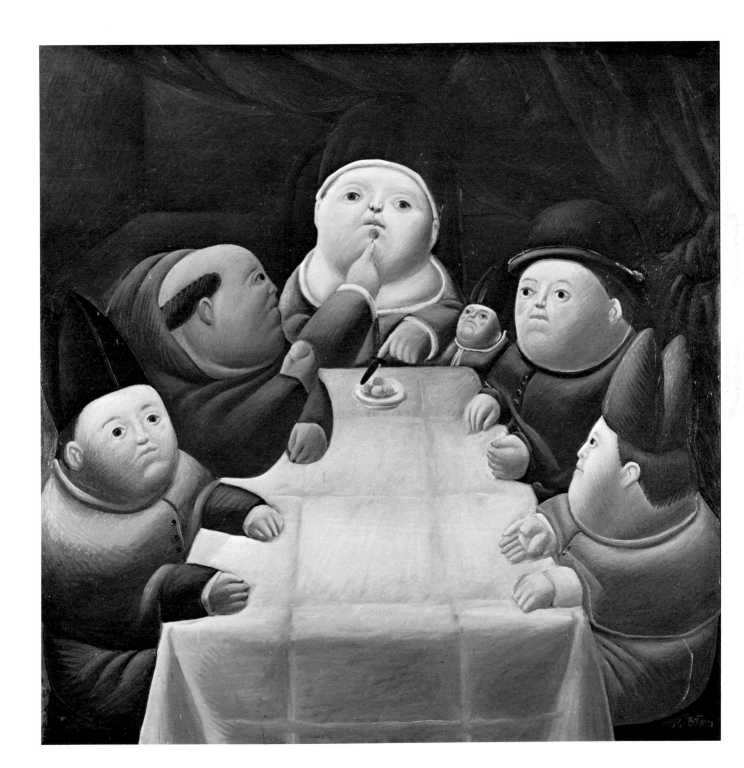

Old Masters

Botero's early styles were much influenced by artists he admired. In his mature work, however, the style was his own, but the subject matter came from Old Masters. Botero's copies of Old Masters constitute his boldest proclamation of his place in Western art tradition: "If I paint a painting that has the same subject as a famous painter has used, I am part of the same tradition. I am saying that I am equal to the artist who first painted that painting."

8.
Woman Crying, 1949
Watercolor on paper, 59.2 x 43.7 (22⅜ x 17¼)
Collection of the artist
See color plate, p. 25

This watercolor, painted in Medellín, was reproduced on the cover of the checklist for Botero's first solo show. The artist now finds in this work "the tremendous sentimentality characteristic of art of the young." The forms and the emotional intensity reflect the influence of the Mexican muralists, particularly Orozco. "I was so excited by Orozco . . . every time I saw something new, it had an influence on my work."

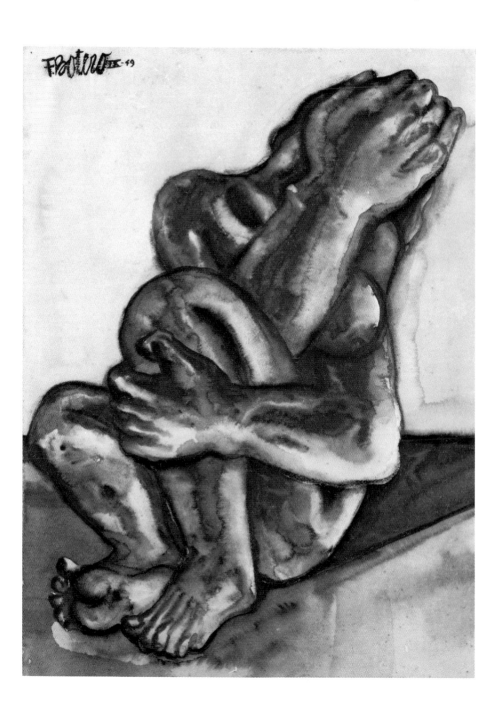

9.
The Departure, 1953
Oil on canvas, 111.8 x 149.9 (44 x 59)
H. J. Kicherer, Rockville, Maryland

Executed at a time when Botero was consciously mimicking effects in the works of other artists, this painting has horses based on those in the *Battle of San Romano,* c. 1455, by Paolo Uccello and an eerie atmosphere that is an attempt to imitate the character of paintings by Giorgio de Chirico. "De Chirico was conscious of this tradition in Italian painting. For me it was important to see paintings done in that spirit."

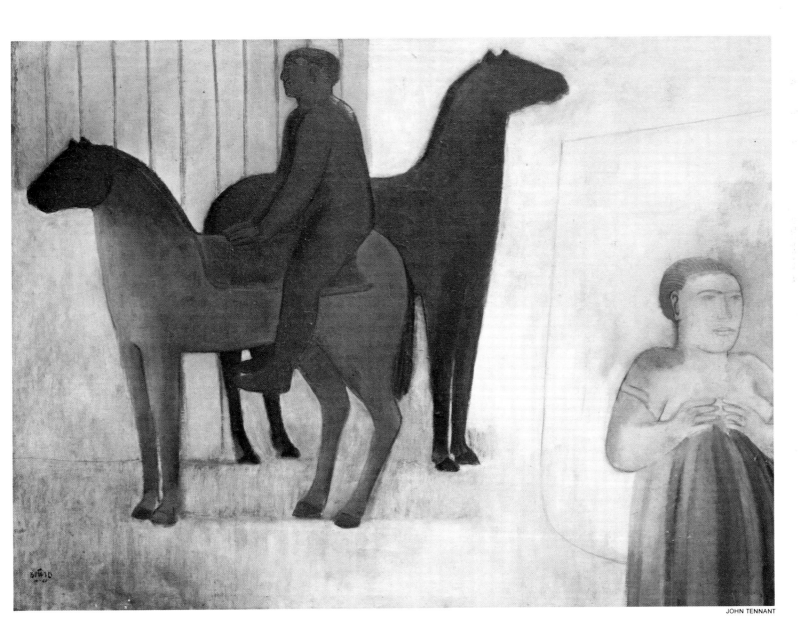

JOHN TENNANT

10.
Camera degli Sposi
(Homage to Mantegna) I, 1958
Oil on canvas, 170.2 x 200.6 (67 x 79)
Patrick B. McGinnis, New York

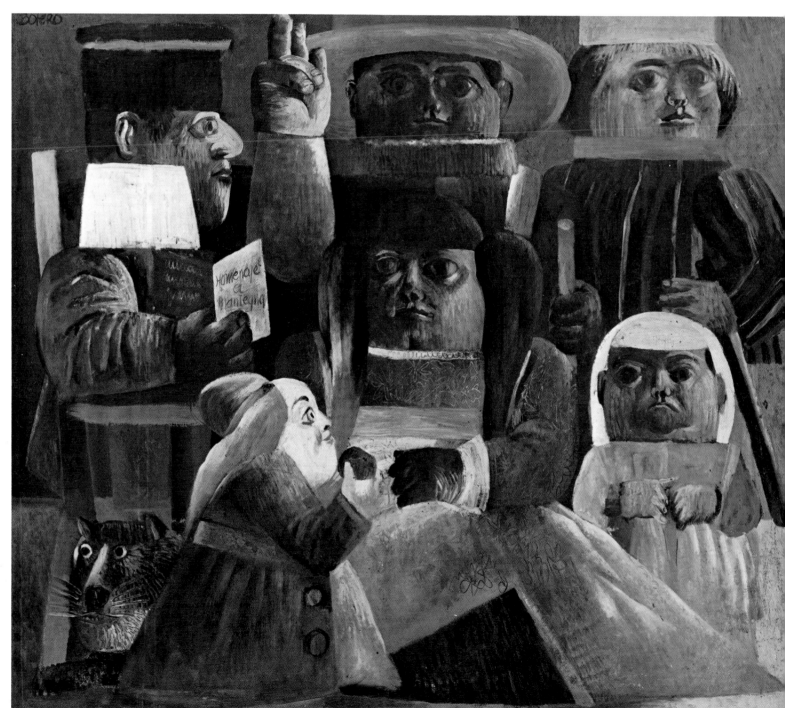

Botero has combined, condensed, and distorted the figures from Andrea Mantegna's frescoes *The Gonzaga Court* and *Lodovico Gonzaga Greeting His Son the Cardinal*, in the Camera degli Sposi, Palazzo Ducale, Mantua. By flattening the figures so that they become elements of a two-dimensional pattern, he intentionally destroys the illusion of three-dimensional space that Mantegna had created. Botero's work won the first prize for painting in the *XI salón anual de artistas colombianos*, Bogotá, in September 1958.

Andrea Mantegna (Italian, c. 1431–1506)
The Gonzaga Court, 1474
Lodovico Gonzaga Greeting His Son the Cardinal, 1474
Camera degli Sposi, Palazzo Ducale, Mantua

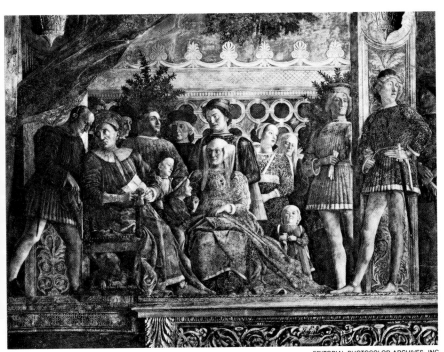

11.
El Niño de Vallecas
(after Velázquez), 1959
Oil on canvas, 133.7 x 143.2 (52⅝ x 56⅜)
The Baltimore Museum of Art
Gift of Geoffrey Gates

"This very Expressionist kind of work was a con-
tradiction of what I did before. I did ten or
eleven versions of the *Niño* in a month's time.
They were very sensual in the application of
color: perhaps there was the influence of the
American Action Painters. I was living in
Bogotá, but I had been two times to New York;
I more or less knew what was going on, and I
was starting to have doubts."

12.
Mona Lisa, Age Twelve, 1959
Oil on canvas, 211 x 195.5 (83 x 77)
The Museum of Modern Art, New York
Inter-American Fund, 1961

It was only after the fact that the artist realized
he had put Mona Lisa's smile on the face of the
young girl he was painting, but after the
realization, he emphasized the resemblance
and produced a series of works by this title. This
painting was hung in the lobby of the Museum
of Modern Art to coincide with the display of
Leonardo's *Mona Lisa* at the Metropolitan
Museum of Art in 1963.

Diego Rodríguez de Silva y Velázquez
(Spanish, 1599–1660)
El Niño de Vallecas, 1643–45
Museo del Prado, Madrid

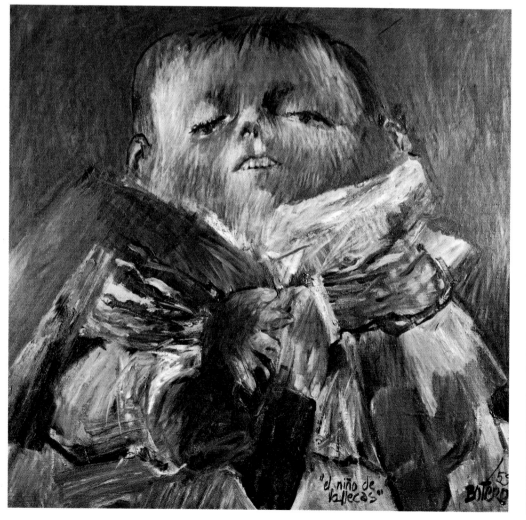

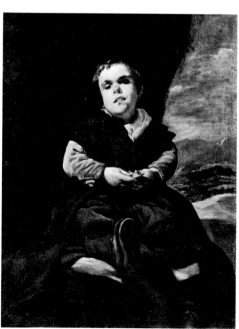

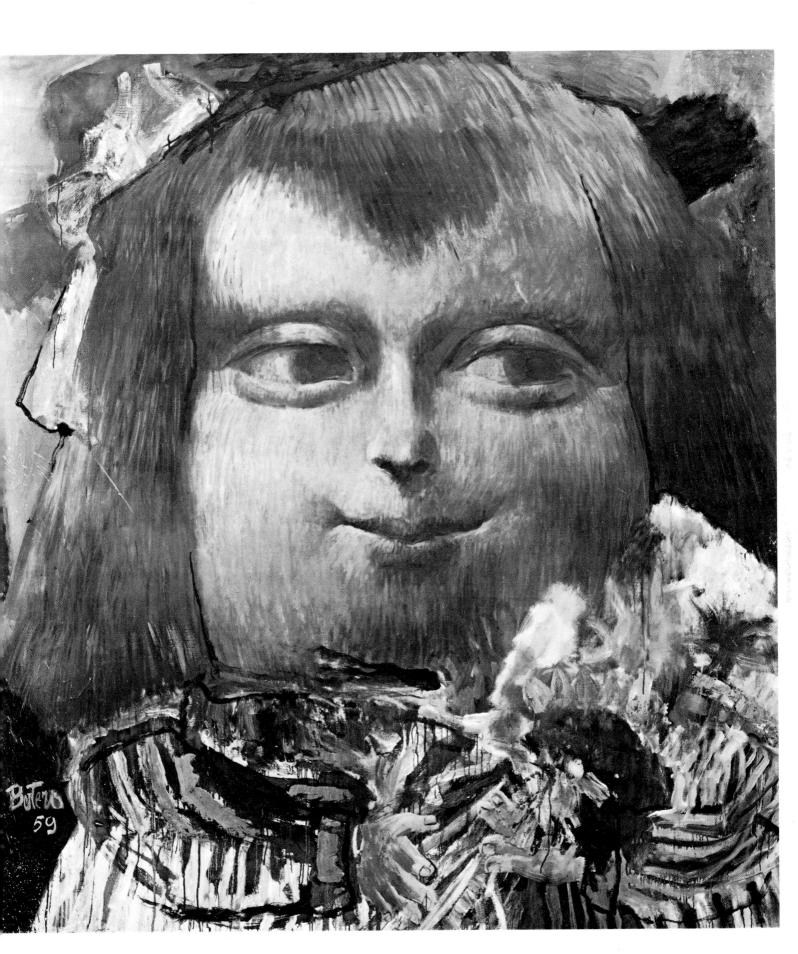

13.
Camera degli Sposi
(Homage to Mantegna) II, 1961
Oil on canvas, 231.5 x 260.3 (90⅛ x 102½)
Hirshhorn Museum and Sculpture Garden,
Smithsonian Institution, Washington, D.C.
See color plate, p. 26

These same six figures from Mantegna's
celebrated frescoes are seen in Botero's *Camera
degli Sposi (Homage to Mantegna) I* of 1958
[10], but here they are painted more freely.
"This is a painting that is flirting with the New
York School, that wanted to be something else
and shows all sorts of incertitudes."

Masaccio (Italian, 1401–1428[?])
Distribution of the Goods of the Church, 1427
Capella Brancacci, Florence

14.
After Masaccio, 1962
Charcoal on paper, 122.9 x 101.6 (48 x 40)
Galería Botello, San Juan, Puerto Rico

This drawing is based on a figure from Masaccio's fresco, *Distribution of the Goods of the Church,* 1427.
"In Italy, I discovered Masaccio—the most dramatic pictures in the world."

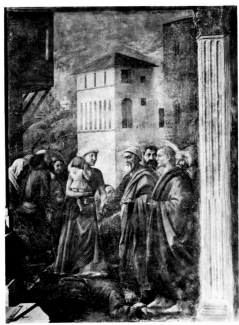

EDITORIAL PHOTOCOLOR ARCHIVES, INC.

JOHN TENNANT

*15.
Rubens' Woman, 1963
Oil on canvas, 177.8 x 182.9 (70 x 72)
The Solomon R. Guggenheim Museum,
New York
Gift Fundación Neumann, Caracas

Botero's transformation of Rubens's *Le chapeau
de paille (Portrait of Susanne Fourmant),* c.
1620, belongs to a series of variations he did on
that painting during the 1960s.

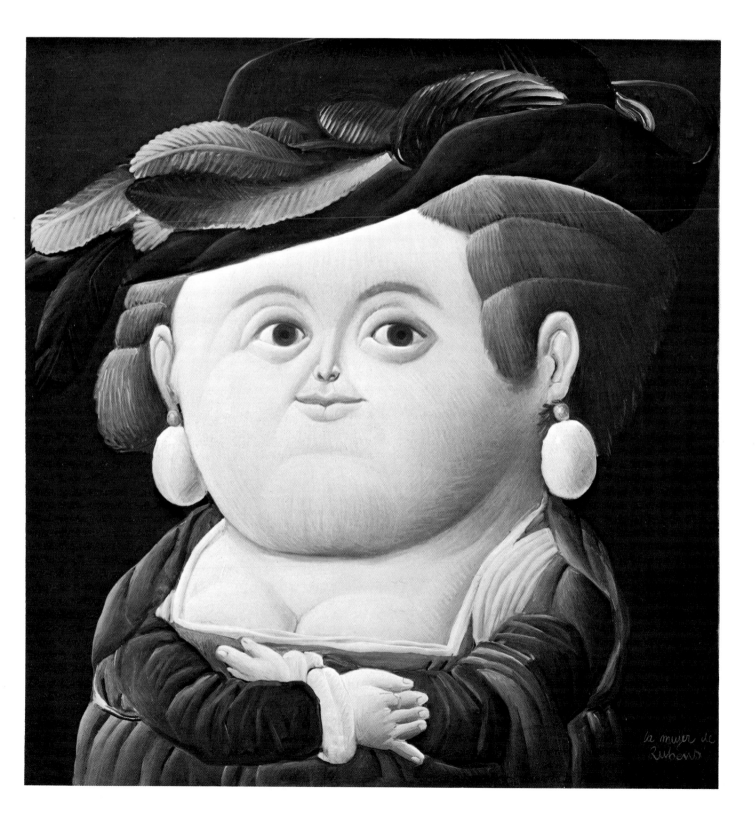

16.
Los Arnolfini 3, 1964
Oil on canvas, 96.5 x 99.1 (38 x 39)
Mr. and Mrs. Mackenzie Gordon,
Washington, D.C.
See color plate, p. 27

In *Los Arnolfini 3,* Botero has simplified the
setting and inflated the figures of Jan van
Eyck's double portrait, *The Arnolfini Marriage,*
1434, to conform to his own principles of
composition.

Drawing for *Los Arnolfini 3*
Collection of the artist
(not in exhibition)

Jan van Eyck (Flemish, c. 1385–1441)
The Arnolfini Marriage, 1434
The National Gallery, London

JOHN TENNANT

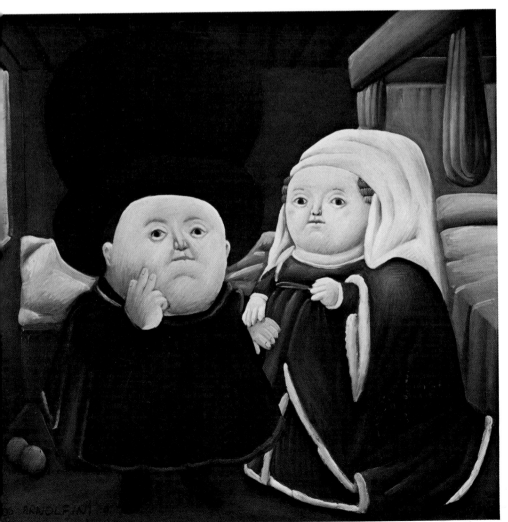

TENNANT

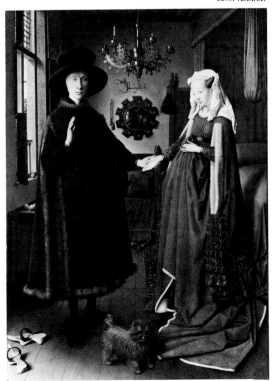

17.
Louis XVI and His Family in Prison (after an Old Engraving), 1968
Charcoal on canvas, 187.9 x 185.4 (74 x 73)
Aberbach Fine Art, New York

Botero recalls that his inspiration for this drawing was an engraving he saw illustrated in *Time*.

18.
Self-Portrait with Mme. Pompadour, 1969
Oil on canvas, 243.4 x 166.5 (95¹³⁄₁₆ x 65⁹⁄₁₆)
Joachim Jean Aberbach, New York

"The self-portraits are satires on myself. Always. I never did a self-portrait as a self-portrait."

19.
Alof de Vignancourt
(after Caravaggio), 1974
Oil on canvas, 254 x 190.5 (100 x 75)
Mr. and Mrs. Carlos Haime, New York
See color plate, p. 37

In this copy of Caravaggio's *Alof de Vignan-court,* c. 1608, considered by Botero to be his masterpiece of technical facility, he mimics Caravaggio's virtuosity while maintaining his own distinctive style. Especially in the rendering of armor, *Alof de Vignancourt (after Cara-vaggio)* constituted Botero's "degree in craftsmanship." Not long after its completion, he turned to sculpture in order to, among other reasons, "get back to basics."

Michelangelo Merisi da Caravaggio
(Italian, 1573–1610)
Alof de Vignancourt, c. 1608
Musée du Louvre, Paris

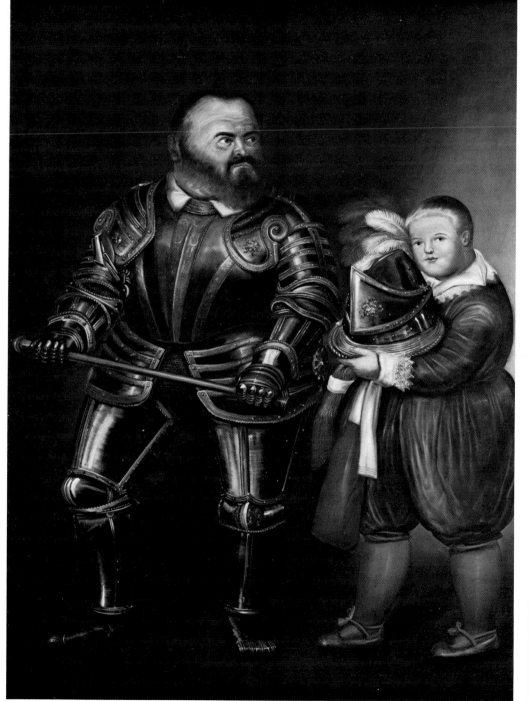

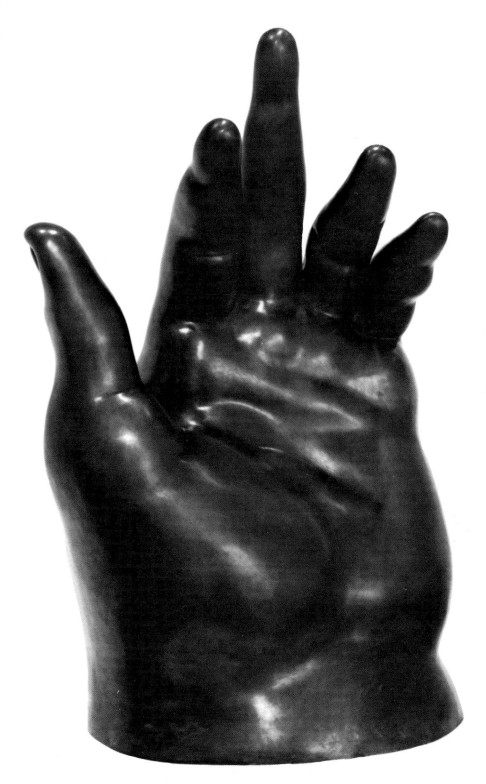

20.
The Big Hand, 1976–77
Bronze (3/6),
87.6 x 56.5 x 46 (34¼ x 22¼ x 18⅛)
Hirshhorn Museum and Sculpture Garden,
Smithsonian Institution, Washington, D.C.
Museum purchase, 1978

According to Botero, "*The Big Hand* comes out
of a finger of the *Victory of Samothrace* in the
Louvre." It is the only sculpture that he has had
cast in two different sizes; the other version is
less than half as tall.

Still and Animate Lifes

As elements in his compositions, Botero's people, animals, and objects often seem interchangeable. In all his work, he always begins with a sketch. "But I have to invent the color. For instance I put a woman, a nude in the painting. I do the color of the skin, let's say, but then I need to make the color jump somewhere. 'How about a piece of cloth on the floor?' Then I put something there in a more or less sketchy way. 'How about a piece of furniture?' The color is the thing that imposes so many elements in the tableau."

21.
The Rooster, 1956
Paper, tempera, crayon, watercolor, and pencil on paperboard, 67.9 x 93.2 (26¾ x 36¾)
Ambassador and Mrs. José Camacho-Lorenzana, Washington, D.C.

This work was executed at a time when Botero was still heavily influenced by other artists, in this case Alejandro Obregón.

JOHN TENNANT

22.
Still Life, 1957
Oil on canvas, 66.7 x 121.3 (26¼ x 47¾)
David Barrett, New York

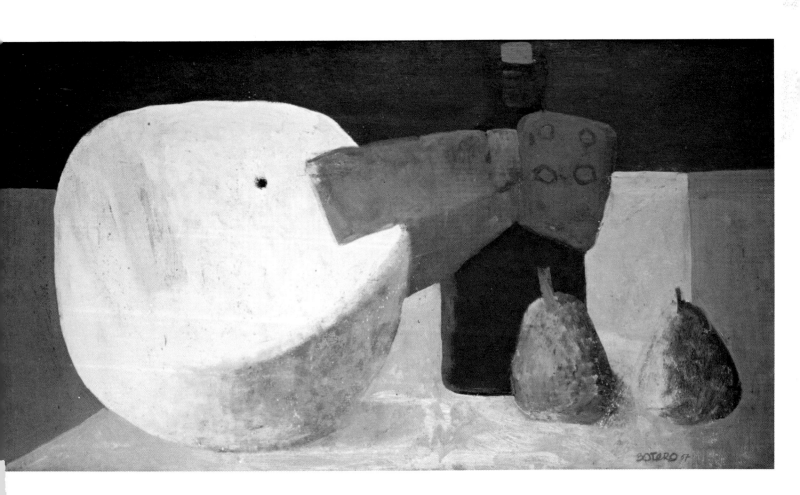

23.
The Apple, 1958
Oil on canvas, 40 x 50.2 (15¾ x 19¾)
Delmar D. Hendricks, New York

"There is something original about taking an apple and putting it right in the center of the composition. I was trying to communicate so much with this little subject, to make it like a bomb that will explode, that in the end it becomes a strange presence."

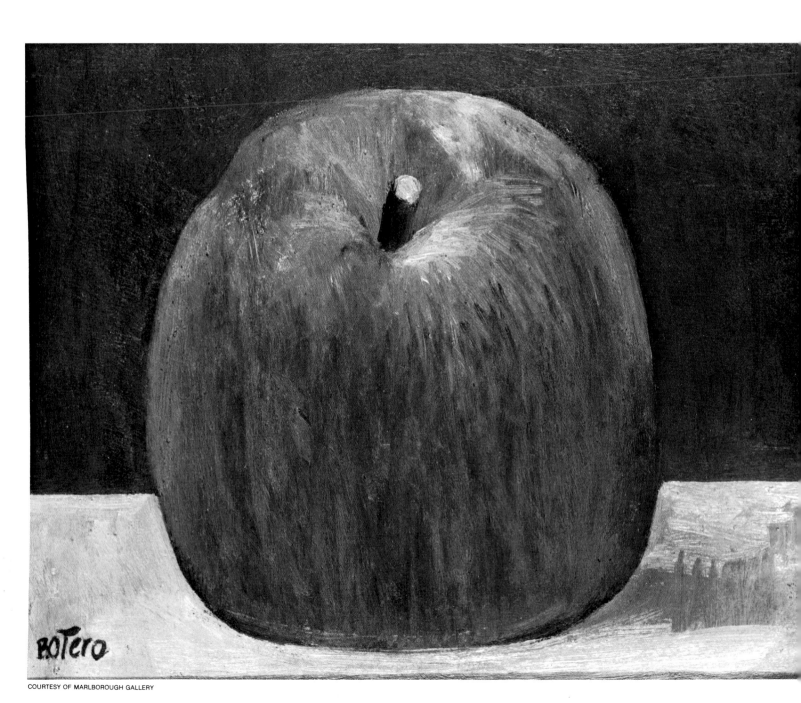

24.
Chromatic Painting, 1963
Oil on canvas, 180 x 180 (71 x 71)
Juan David Botero, Bogotá

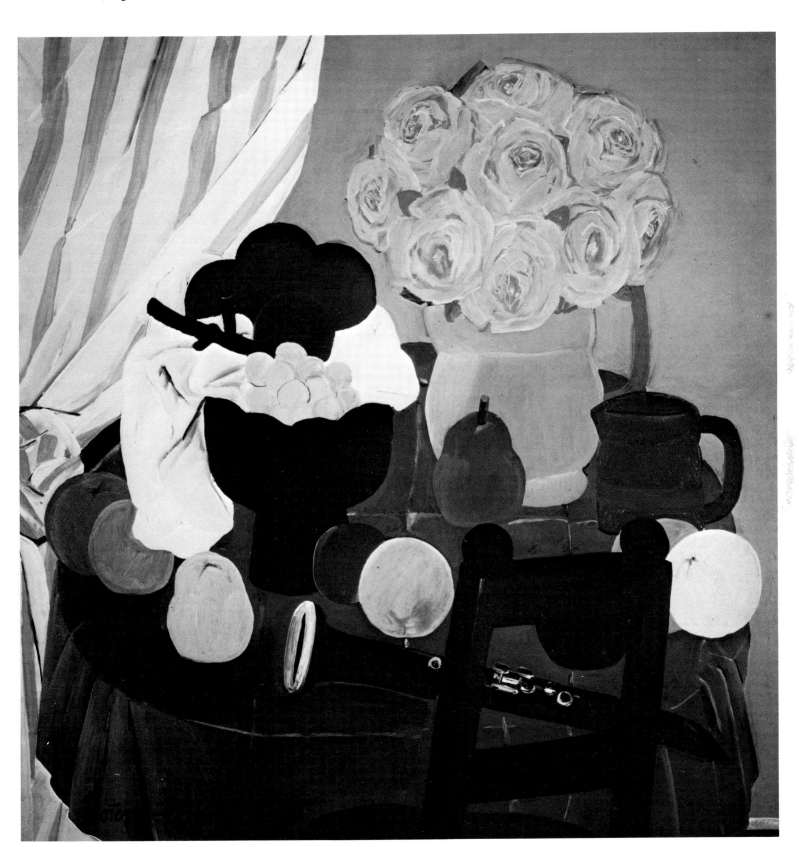

25.
Apples (Fruit), 1964
Oil on canvas, 127.3 x 130.8 (50⅛ x 51½)
The Lowe Art Museum, The University of Miami,
Coral Gables, Florida
Gift of Esso Inter-America, Inc.

This painting received first prize for painting at
the *Primer salón Intercol de artistas jóvenes*
at the Museo de Arte Moderno in Bogotá.

"I was fighting against New York. There was a
big, big struggle in this painting."

*26.
The Cupboard, 1970
Oil on canvas, 184.1 x 167.6 (72½ x 66)
Mr. and Mrs. Peter Findlay, New York

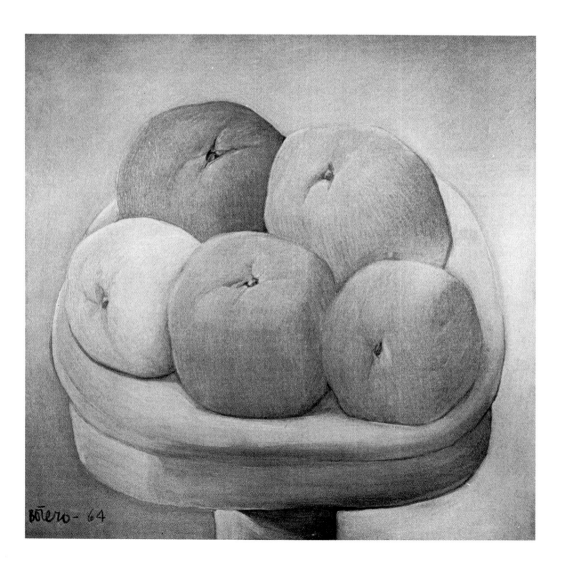

27.
Flowers, 1970
Oil on canvas, 193 x 144.8 (76 x 57)
Julian J. Aberbach, Paris

Drawing for *Flowers*
Collection of the artist
(not in exhibition)

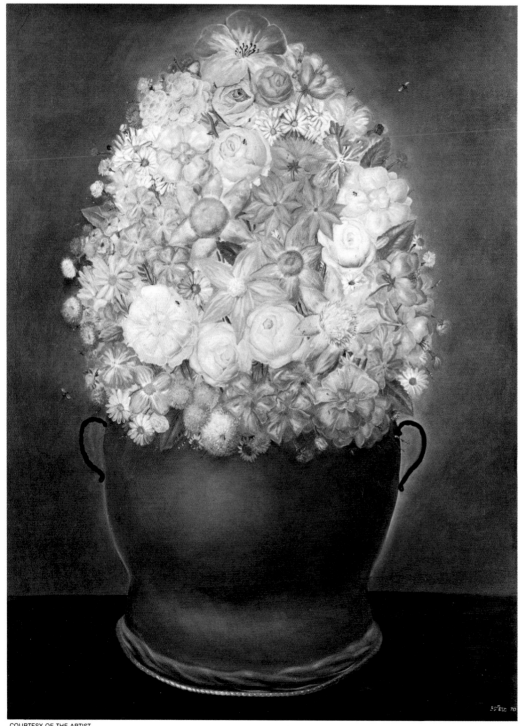

COURTESY OF THE ARTIST

JOHN TENNANT

28.
The Stove, 1970
Oil on canvas, 186.7 x 148.6 (73½ x 58½)
Sydney and Frances Lewis, Richmond, Virginia

Although this kitchen scene is typically Colombian, the painting was done in Botero's studio on Stephen's Hand Pass Road, Easthampton, Long Island.

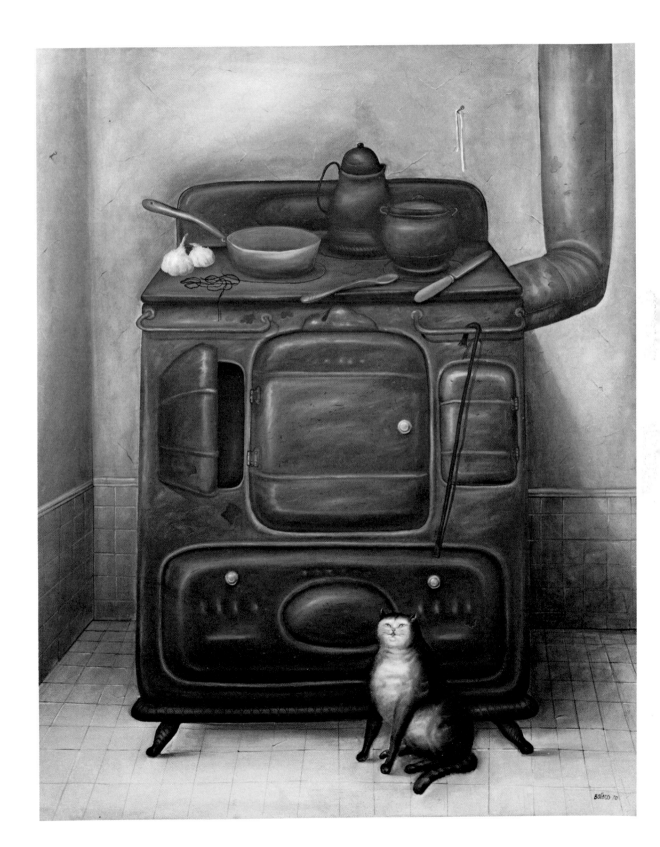

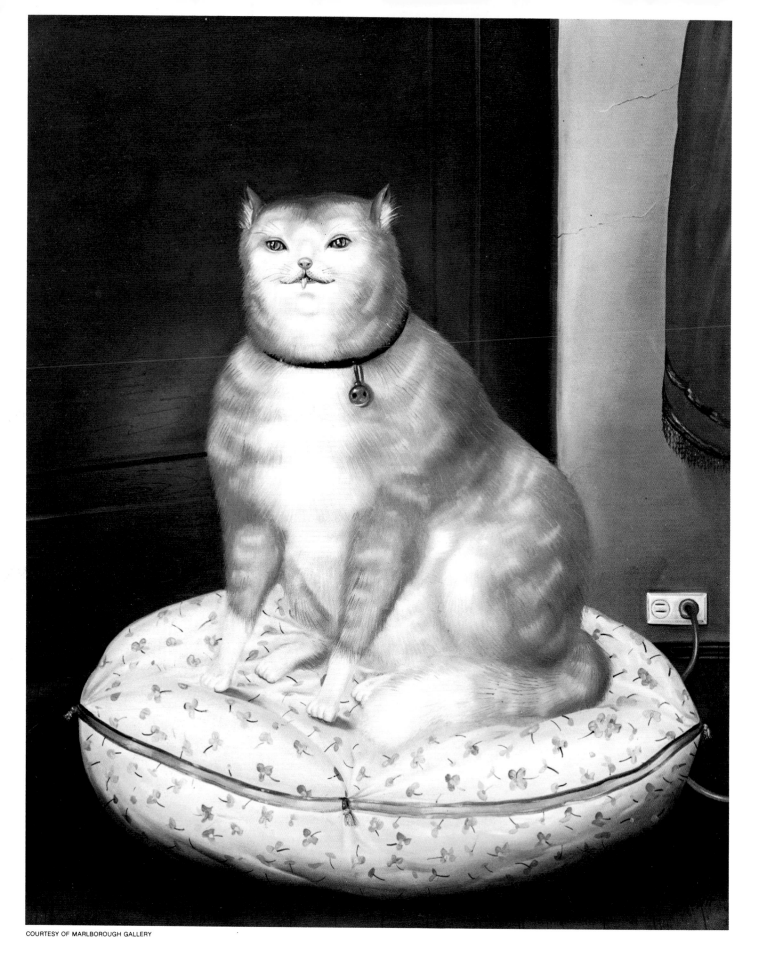

29.
The Cat, 1971
Oil on canvas, 114.3 x 91.4 (45 x 36)
Julio Mario Santo Domingo, New York
See color plate, p. 33

30.
Pineapples, 1971
Oil on canvas, 163.8 x 193 (64¼ x 76)
Mr. and Mrs. Stanley Westreich,
Bethesda, Maryland

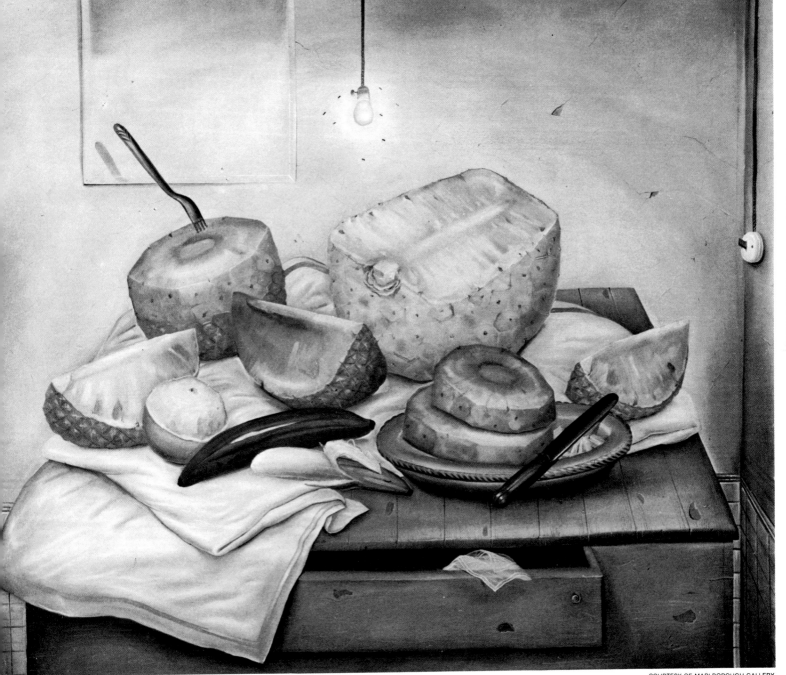

31.
Fruit Basket, 1972
Pastel on paper, 123 x 141 (48½ x 55½)
Mr. and Mrs. Carlos Haime, New York

Drawing for *Fruit Basket*
Collection of the artist
(not in exhibition)

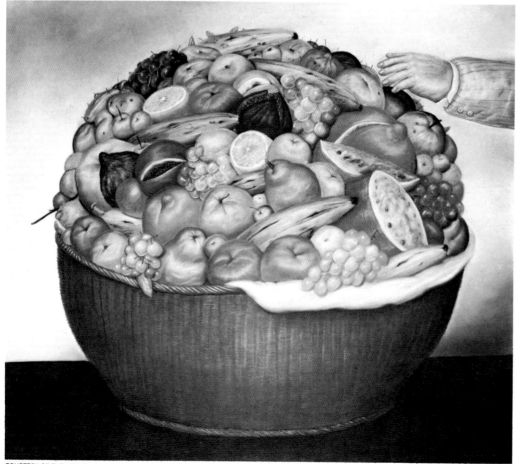

COURTESY OF THE ARTIST

JOHN TENNANT

32.
Onions, 1974
Oil on canvas, 138.4 x 153.7 (54½ x 60½)
Mr. and Mrs. Leigh B. Block, Chicago
See color plate, p. 36

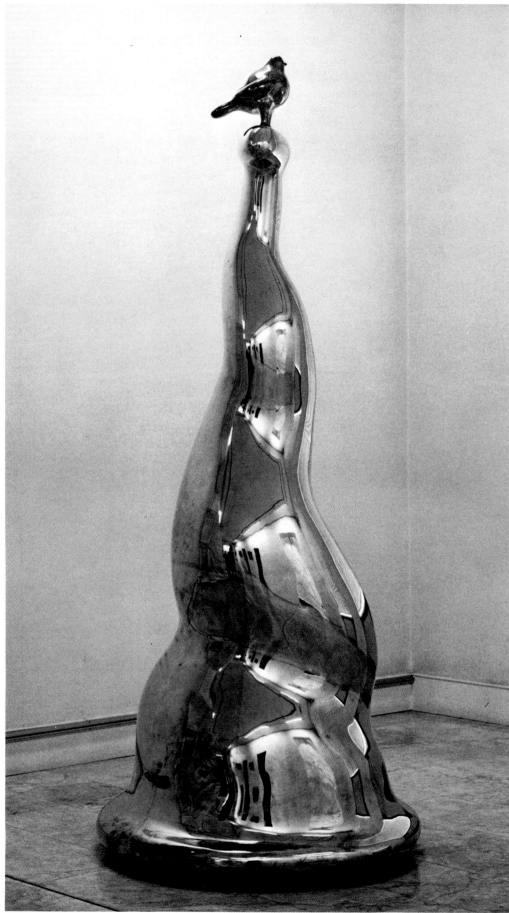

33.
Bird on a Column, 1976
Bronze (edition of 6),
219 x 88 x 88 (86¼ x 34⅝ x 34⅝)
Marlborough Gallery, New York

34.
Landscape with Trees, 1979
Oil on canvas, 233.7 x 308.6 (92 x 121⅜)
Marlborough Gallery, New York

35.
Still Life in Front of a Window, 1979
Oil on canvas, 189.2 x 145.5 (74½ x 57¼)
Marlborough Gallery, New York
See color plate, p. 40

Nudes and Sexual Mores

Botero distorts the human figure but he is, nevertheless, very interested in exploring every detail of it. His exploration of modern mores in paintings of brothels and other scenes suggests his sense of humor rather than any moral judgment on his part.

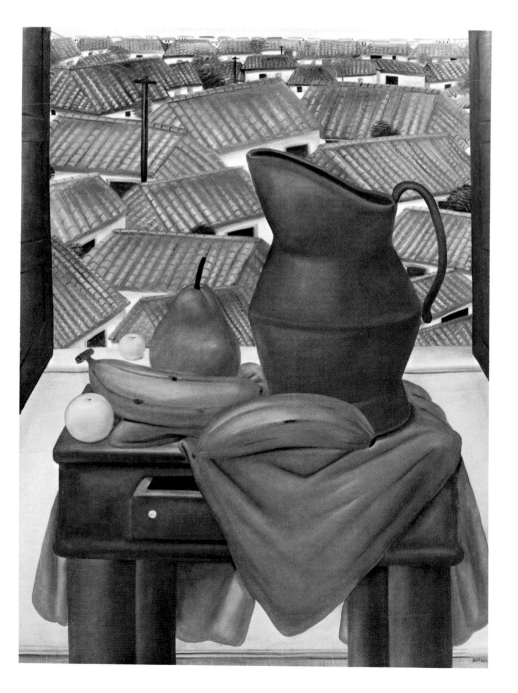

*36.
Reclining Nude, 1966
Charcoal on paper,
170 x 183 (66^{15}/$_{16}$ x 72^{1}/$_{16}$)
Mr. and Mrs. Sidney S. Zlotnick,
Washington, D.C.

37.
Homage to Bonnard, 1968
Oil on canvas, 186.7 x 161.3 (73½ x 63½)
Private collection, New York, courtesy of
Andrew Crispo Gallery, New York

Botero parodies Bonnard with this intentionally
naive interpretation of one of the older artist's
favorite subjects. The homage, however, is sin-
cere, and Botero painted a whole series of
works entitled *Homage to Bonnard*.

38.
The Voyeur, 1969
Oil on canvas, 185.4 x 181.6 (73 x 71½)
Mrs. Shelby White, New York

39.
Melancholic Transvestite, 1970
Oil on canvas, 175.3 x 195.6 (69 x 77)
Julio Mario Santo Domingo, New York
See color plate, p. 32

40.
The House of Ana Molina, 1972
Sanguine on canvas, 195.5 x 170.2 (77 x 67)
Aberbach Fine Art, New York

Like *The House of the Arias Twins* [42], *The House of Ana Molina* represents an actual brothel in Medellín.

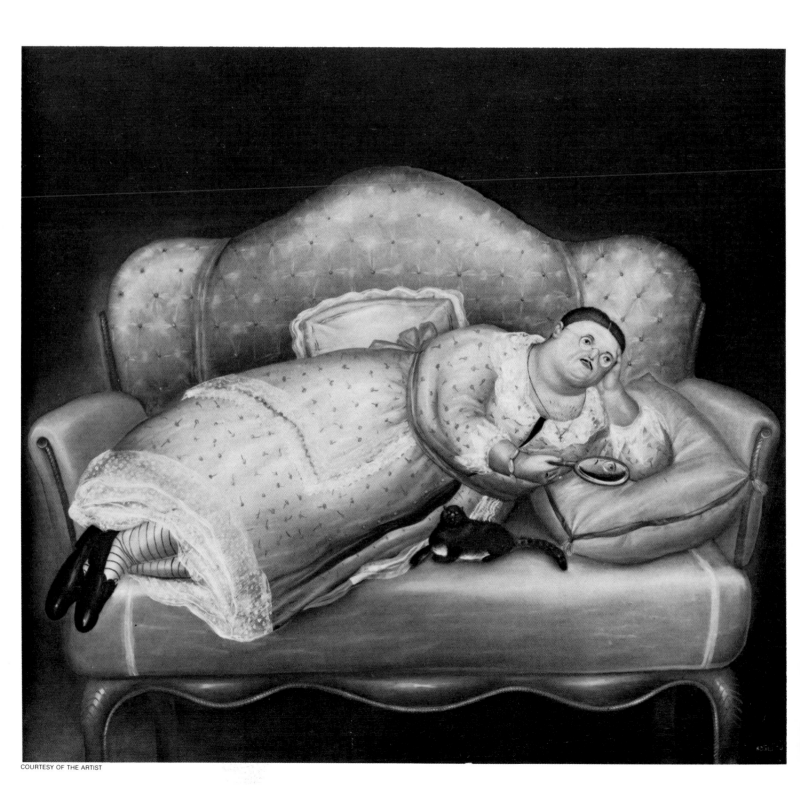

41.
Study of a Male Model, 1972
Pastel, 170.2 x 123.2 (67 x 48½)
Mr. and Mrs. E. A. Bergman, Chicago

Playing on the tradition of the academic study
of the nude, the artist very carefully imitates the
accidental misplacement of a hand and a foot.

*42.
The House of the Arias Twins, 1973
Oil on canvas, 228.6 x 188 (90 x 74)
The Abrams Family Collection, New York

43.
Bathers, 1975
Oil on canvas,
3 panels, each 236.2 x 125.7 (93 x 49½)
Metromedia, Inc., Los Angeles
See color plate, p. 38

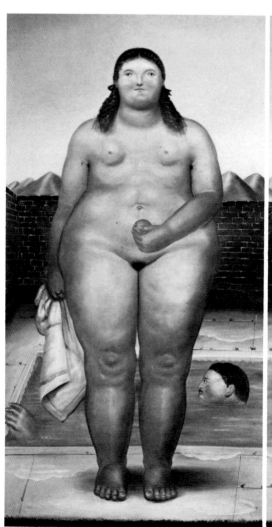
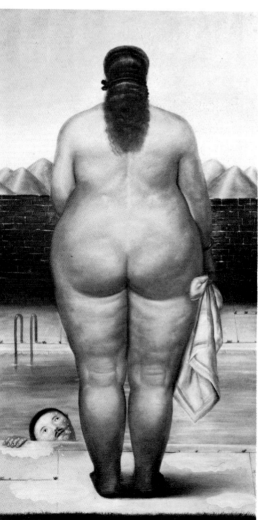
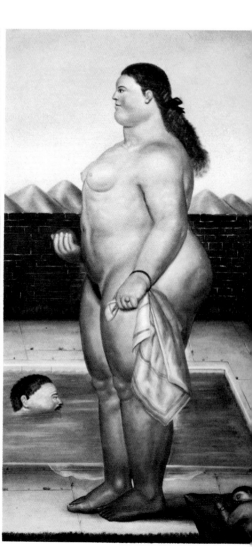

44.
Little Whore, 1975
Pastel on paper, 170.1 x 116.8 (67 x 46)
Mr. and Mrs. Eugene S. Schweig, Jr.,
St. Louis, Missouri

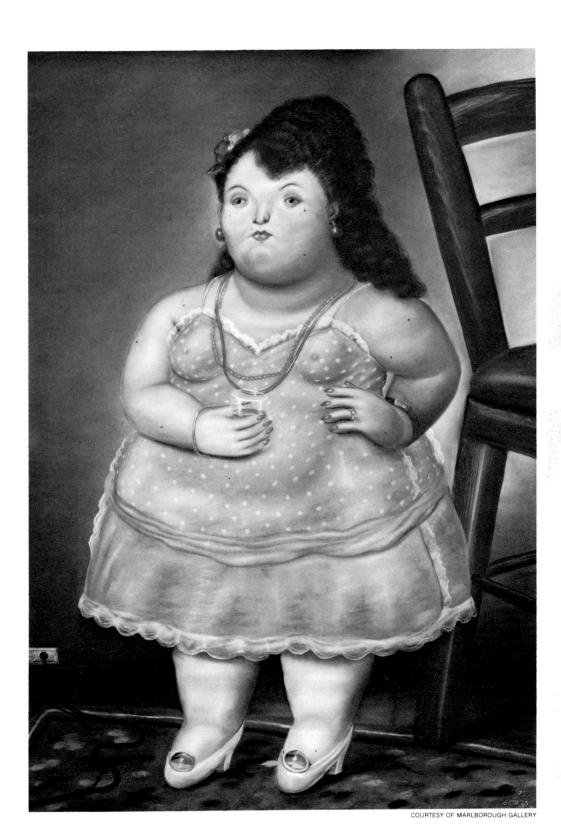

45.
Reclining Woman, 1976
Marble,
39.1 x 88.1 x 50 (15⅜ x 34¹¹⁄₁₆ x 19¹¹⁄₁₆)
Mr. and Mrs. Carlos Haime, New York

The marble *Reclining Nude* is unique, but there
is also a bronze version, less than half as large,
which has been cast in an edition of six.

46.
Little Whore, 1977
Polyester resin (edition of 6),
160 x 81.3 x 76.2 (63 x 32 x 30)
Marlborough Gallery, New York
See color plate, p. 39

"There is a great tradition of polychrome art,
not only in Latin America. I have always been
fascinated by this. There is polychrome
sculpture from all times; most of the great art
of the Greeks was polychrome at the time. . . .
I am such an ambitious artist I want to do
everything."

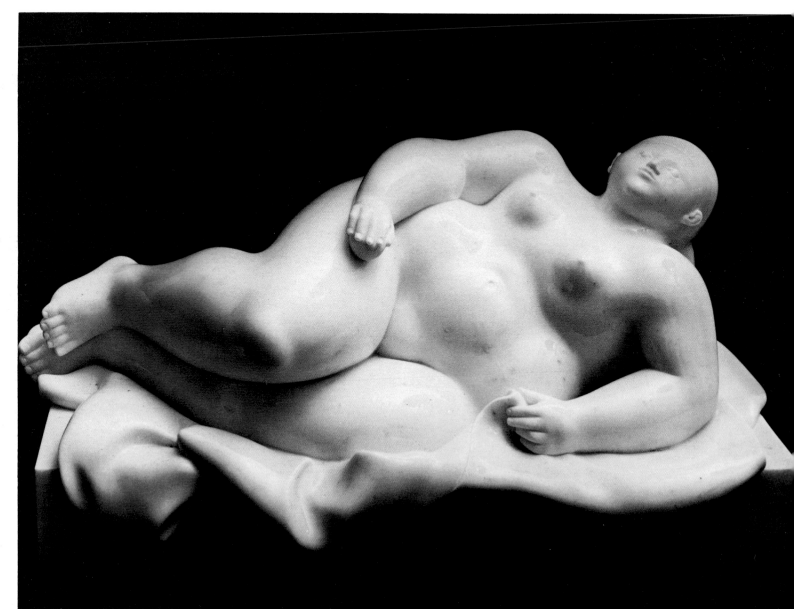

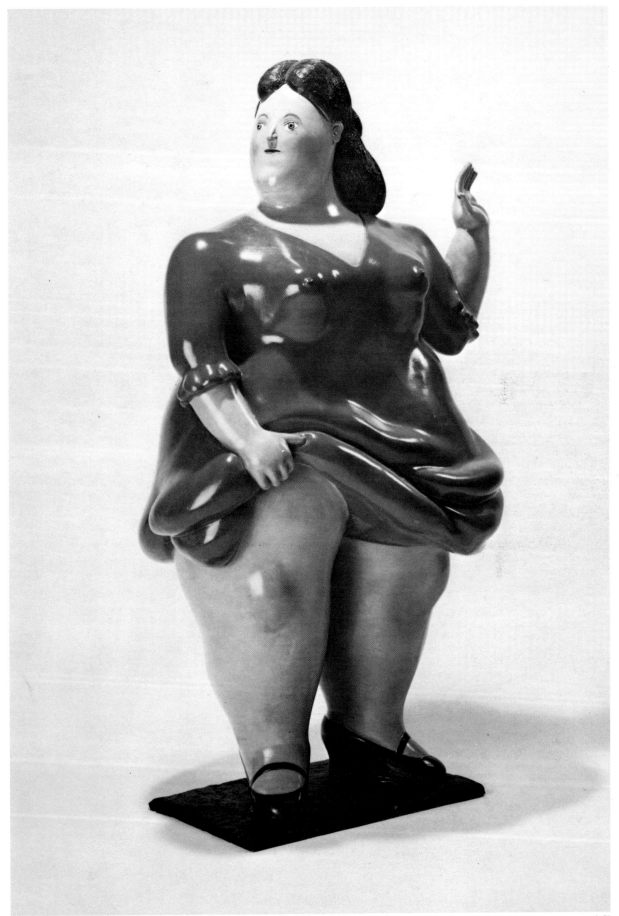

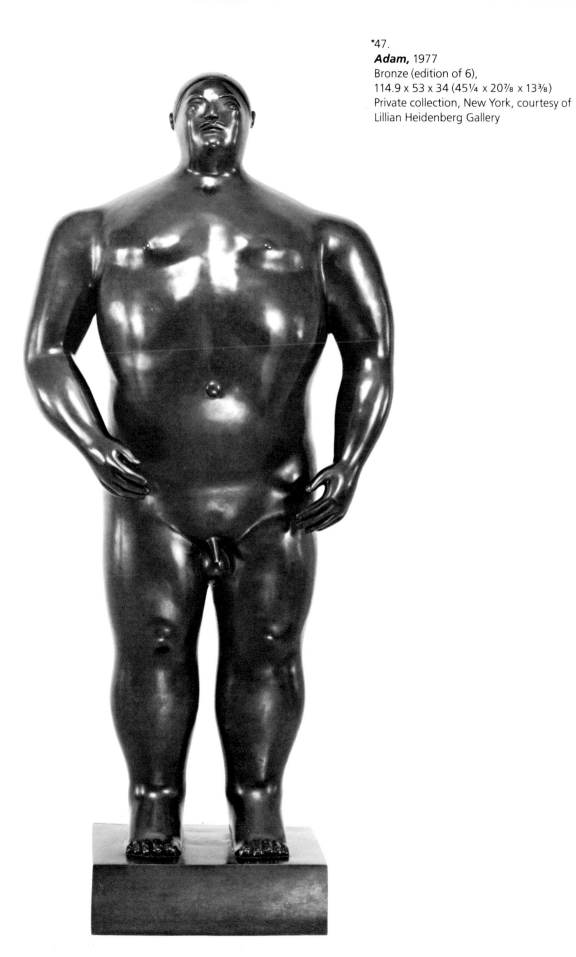

*47.
Adam, 1977
Bronze (edition of 6),
114.9 x 53 x 34 (45¼ x 20⅞ x 13⅜)
Private collection, New York, courtesy of
Lillian Heidenberg Gallery

*48.

Eve, 1977
Bronze (edition of 6),
114.9 x 53 x 34 (45¼ x 20⅞ x 13⅜)
Private collection, New York, courtesy of
Lillian Heidenberg Gallery

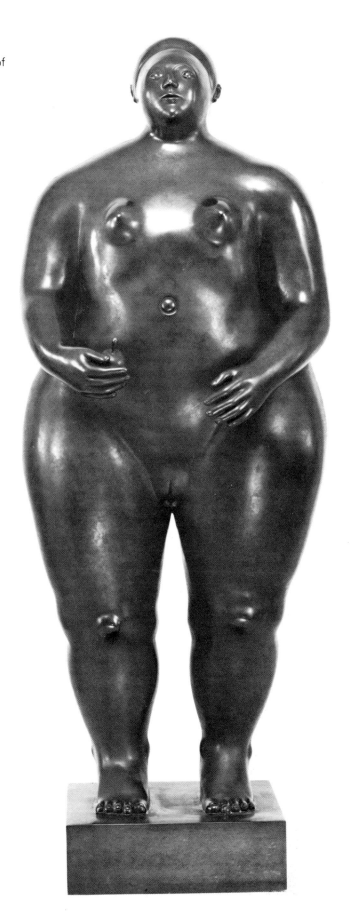

Politics

In Botero's work, political subject matter, like religious subject matter, is important because of its inherent historical nature and not as a strong polemic statement on the part of the artist. "When you see the paintings of Orozco, or the paintings of Grosz in the time of Nazism, it is so clear that these men are hating; in my paintings it is not clear."

Rather than representing particular people, his presidential family, first lady, military junta, and political prisoner are derived from Latin American images that have become clichés—"A cliché is something that is not true, but it is the deepest truth at the same time."

49.
The Boss, 1963
Oil on canvas, 91.4 x 86.4 (36 x 34)
Mr. and Mrs. N. L. Pines, New York

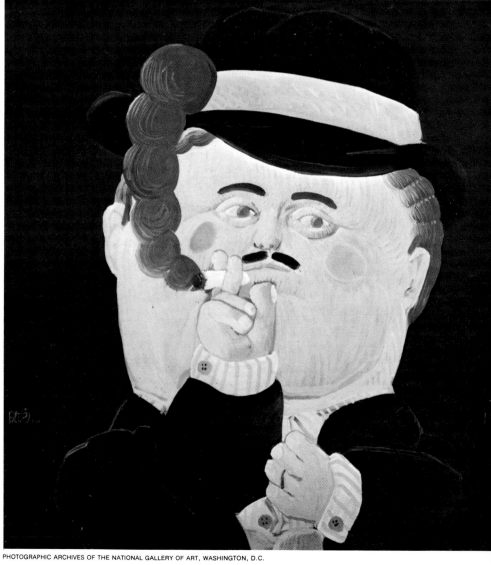

50.
The Presidential Family, 1967
Oil on canvas, 203.5 x 195.5 (79 x 77)
The Museum of Modern Art, New York
Gift of Warren D. Benedek, 1967
See color plate, p. 30

What was far more important to Botero than the depiction of a particular presidential family was the tradition of state portraits—this painting, although Latin American in its details, is a direct descendant of Goya's _The Family of Charles IV_ and Velázquez's _Las Meninas._

"The pomposity of these presidential families that took over Latin American countries like they were their own farms: it was a perfect opportunity to work in the tradition of the court painters, Velázquez, Goya.

"With the kind of painting that I do, you cannot actually show hate. When you look at the painting, you have the feeling that perhaps it is actually love, I carry so much my colors, my forms. Even if I am painting someone I hate, at the end you get a mixed feeling."

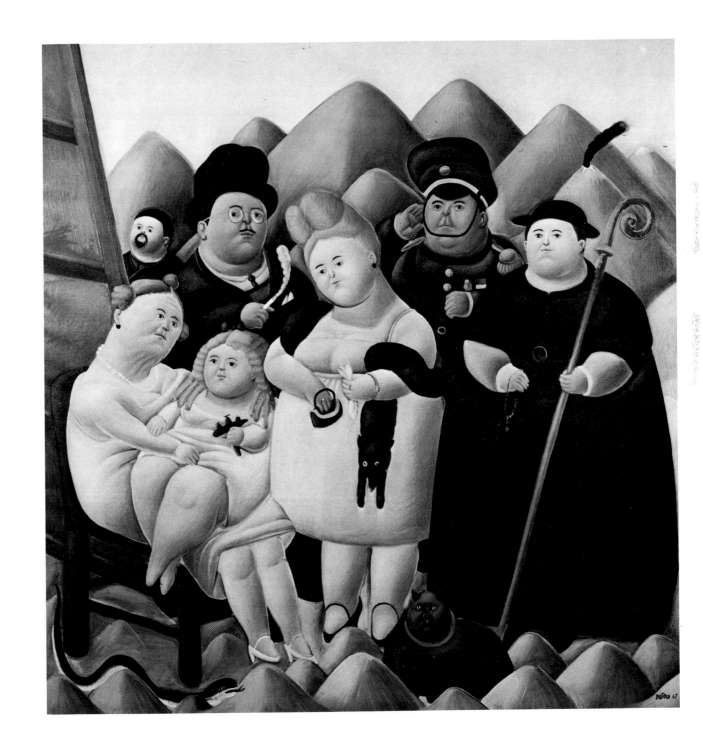

51.
The First Lady, 1969
Oil on canvas, 198.1 x 172.7 (78 x 68)
Mr. and Mrs. Jerome L. Stern, New York

In *The Autumn of the Patriarch (El otoño del patriarca,* 1975), Gabriel García Márquez describes Botero's prototypical first lady, who was "more of a fox than the blue leticias she wore around her neck" and who "carried off everything she found in her path to satisfy the only thing left from her former status as novice which was her childish poor taste and the vice of asking for something when there was no need" [translated by Gregory Rabassa, pp. 182–83 (New York: Harper & Row, 1976)].

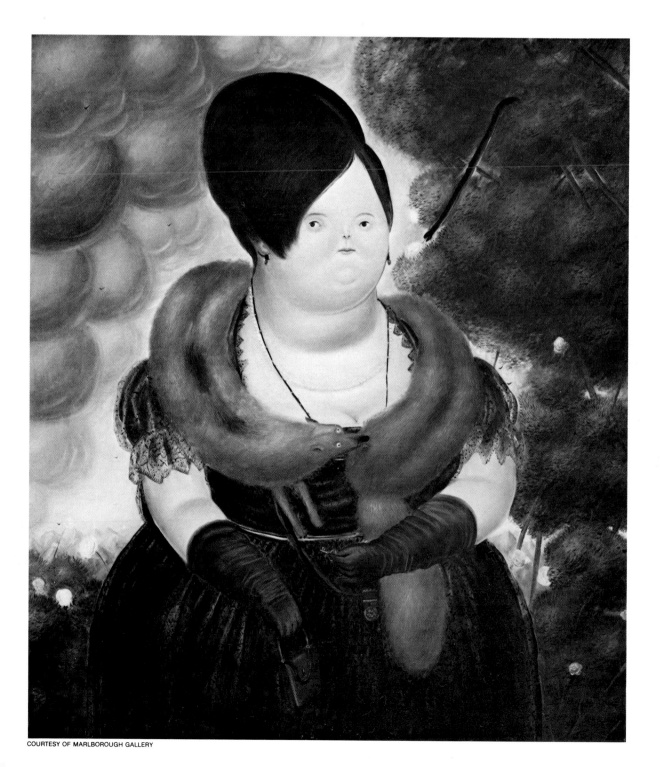

52.
Official Portrait of the
Military Junta, 1971
Oil on canvas, 172.7 x 218.4 (68 x 86)
Joachim Jean Aberbach, New York
See color plate, p. 34

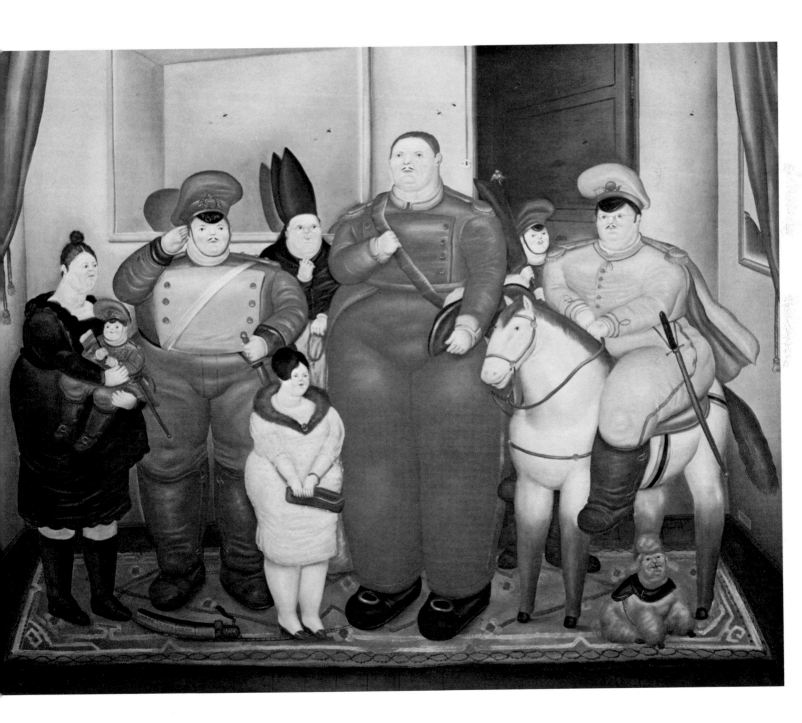

53.
Political Prisoner, 1972
Oil on canvas, 125.7 x 91.4 (49½ x 36)
Dr. Jack E. Chachkes, New York

"About twenty-five years ago the political prisoner was the thing in the air; . . . there was even a contest in Europe for a sculpture.

"What I did in a way was a satire. When I did that personage, I wasn't thinking that he was going to be a political prisoner, and suddenly I said, 'Why not?' But that's the way I sometimes work."

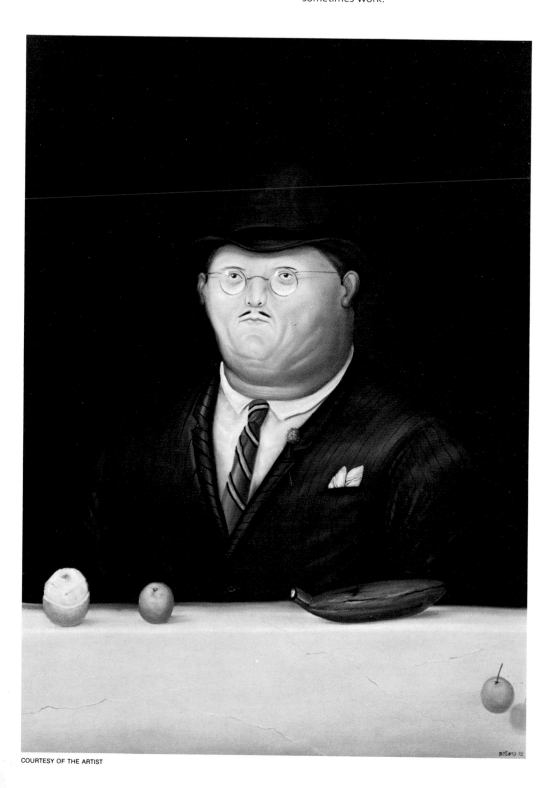

54.
War, 1973
Oil on canvas, 190.5 x 279.4 (75 x 110)
Mr. and Mrs. Carlos Haime, New York
See color plate, p. 35

Although triggered by reports of the Yom Kippur war between Israel and its Arab neighbors in 1973, this work, like Gabriel García Márquez's novel *The Autumn of the Patriarch,* is an expression of the kind of senseless devastation that Colombia experienced during "La Violencia."

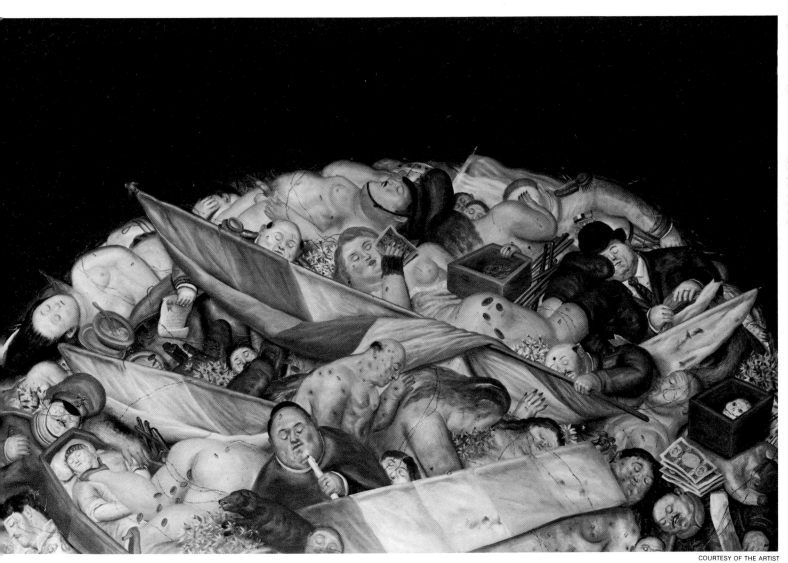

Real and Imaginary People

Although his work is largely derived from remembered images, Botero sometimes begins a sketch in immediate response to clippings from newspapers or magazines. However, he vehemently declares that "never in my life did I use an actual photograph." Although all his people are unmistakably Boteroesque, one can trace the artist's development from *The Boy with Mandolin* [55] to *The Musicians* [66]. "I can't put in my mind that I've done a thousand paintings. I have destroyed so many things. I believe so much in working fast."

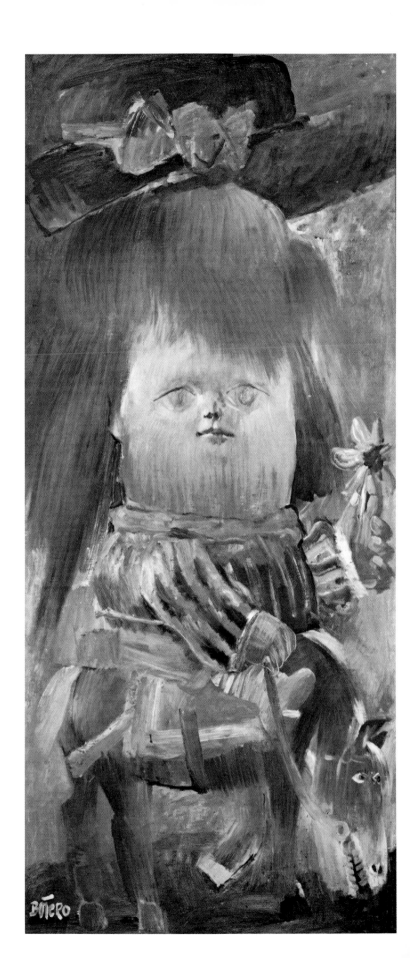

55.
Girl on a Donkey, c. 1959
Oil on canvas, 174 x 76.8 (68½ x 30¼)
Mr. and Mrs. Mauricio Botero, Madrid

Sketch after *Apotheosis of Ramón Hoyos*
Collection of the artist
(not in exhibition)

56.
Apotheosis of Ramón Hoyos, 1959
Oil on canvas, 200 x 300, approximate
 Mr. and Mrs. Diego Llorente, Bogotá
(not illustrated)

Hoyos, Colombia's champion cyclist, was a national hero. This large painting was exhibited at the annual Colombian Salón of 1959.

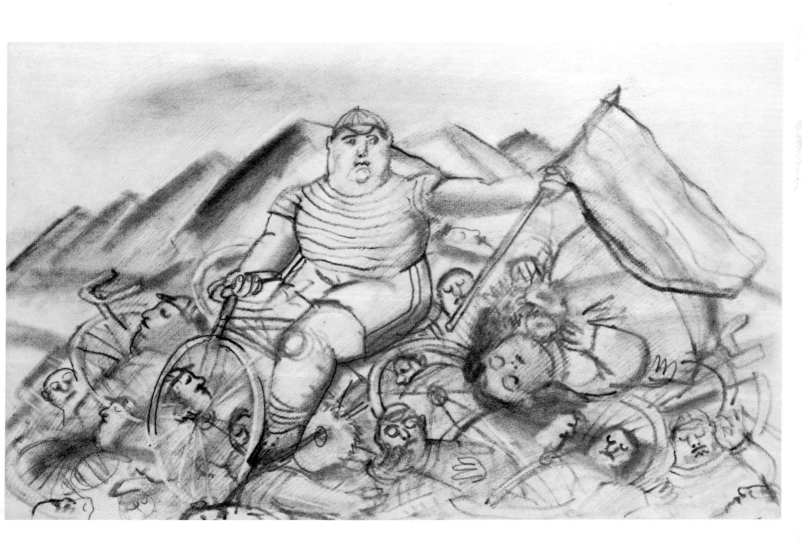

57.
Girl, 1962
Oil on canvas, 180.3 x 172.7 (71 x 68)
Jane and Manuel Greer, New York

58.
The Pinzón Family, 1965
Oil on canvas, 172.7 x 172.7 (68 x 68)
Museum of Art, Rhode Island School
of Design, Providence
Nancy Sales Day Collection of Modern
Latin American Art
See color plate, p. 28

Characteristic of Botero's wit, this painting
shows a prototypical Colombian family rather
than specific members of the Pinzón clan.

59.
The Rich Children, 1966
Oil on canvas, 198.1 x 193 (78 x 76)
Aberbach Fine Art, New York

60.
Portrait of Mr. and Mrs.
Thomas M. Messer, 1968
Oil on canvas, 185.4 x 149.9 (73 x 59)
Mr. and Mrs. Thomas M. Messer, New York
See color plate, p. 31

This painting of the director of the Solomon R.
Guggenheim Museum and his wife was Bo-
tero's first commissioned portrait. The painting
by Wojciech Fangor on the wall behind them
is in the Messers' collection.

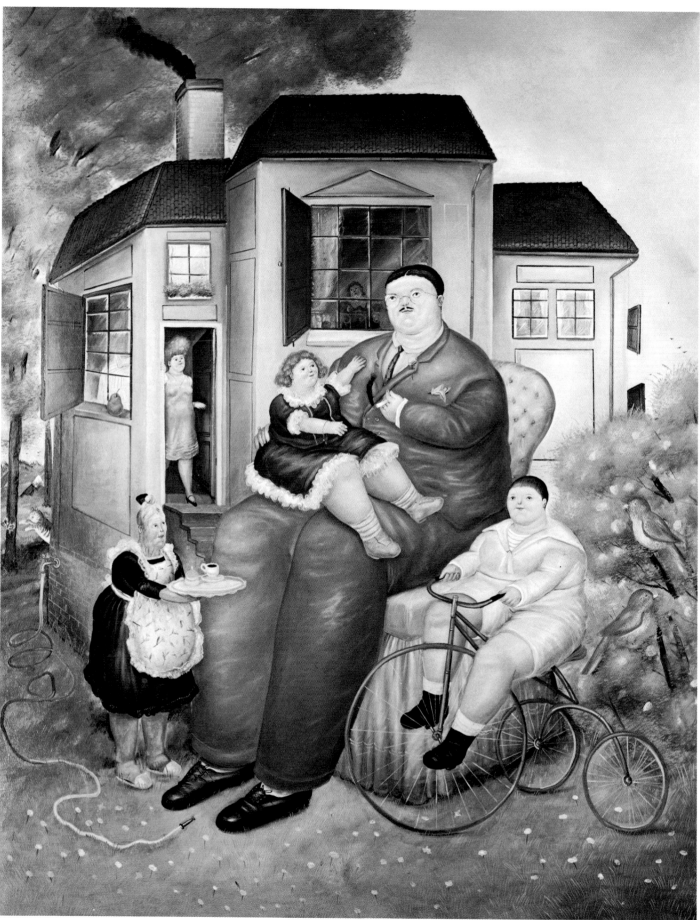

61.
The Coffee Break, 1970
Oil on canvas, 238.8 x 195.6 (94 x 77)
Private collection

62.
The Poet, 1970
Oil on canvas, 94 x 119.4 (37 x 47)
Delmar D. Hendricks, New York

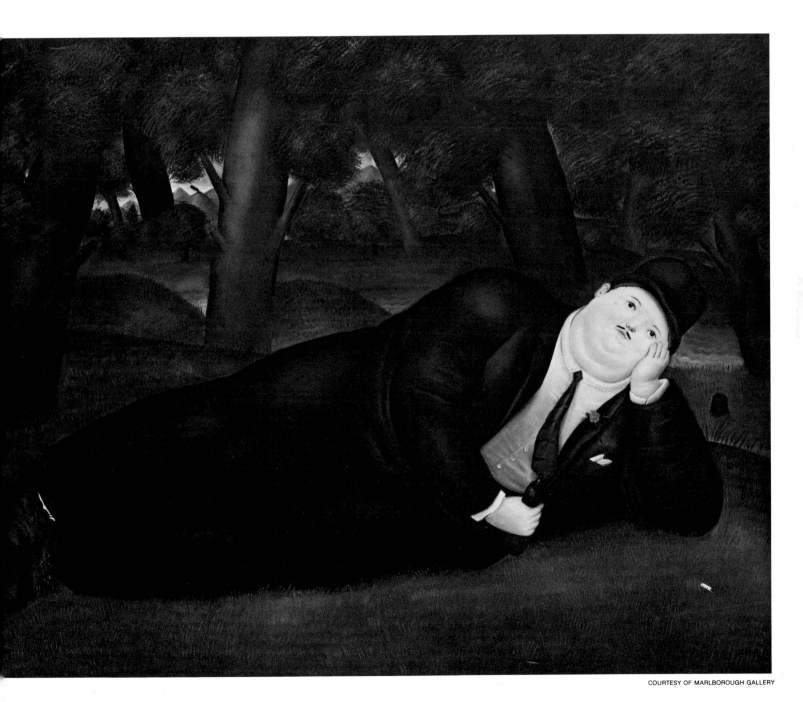

63.
Pedro with Monkey, 1972
Pastel on paper, 149.9 x 109.2 (59 x 43)
Aberbach Fine Art, New York

Drawing for *Pedro with Monkey*
Collection of the artist
(not in exhibition)

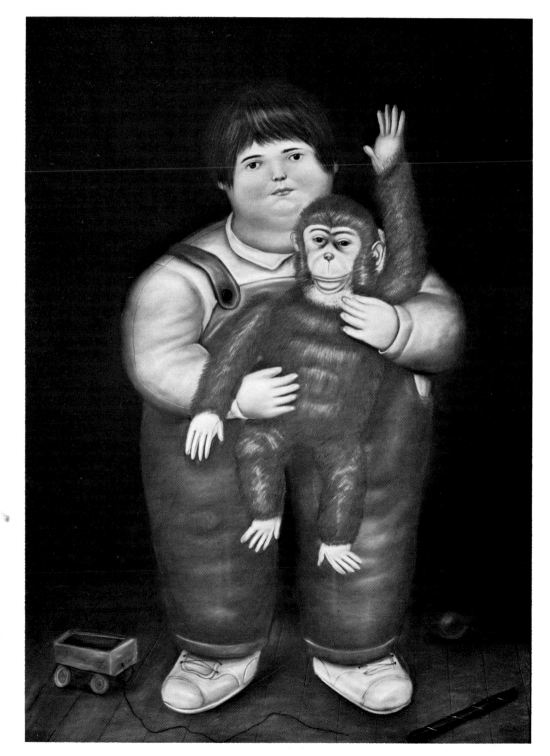

JOHN TENNANT

64.
Painter of Still Lifes, 1975
Pencil on paper, 56.8 x 76.2 (22⅜ x 30)
The Museum of Modern Art, New York
Gift of Mrs. Wolfgang Schoenborn in honor
of René d'Harnoncourt

Although this is not a self-portrait, the child at
the left is Botero's son Pedro.

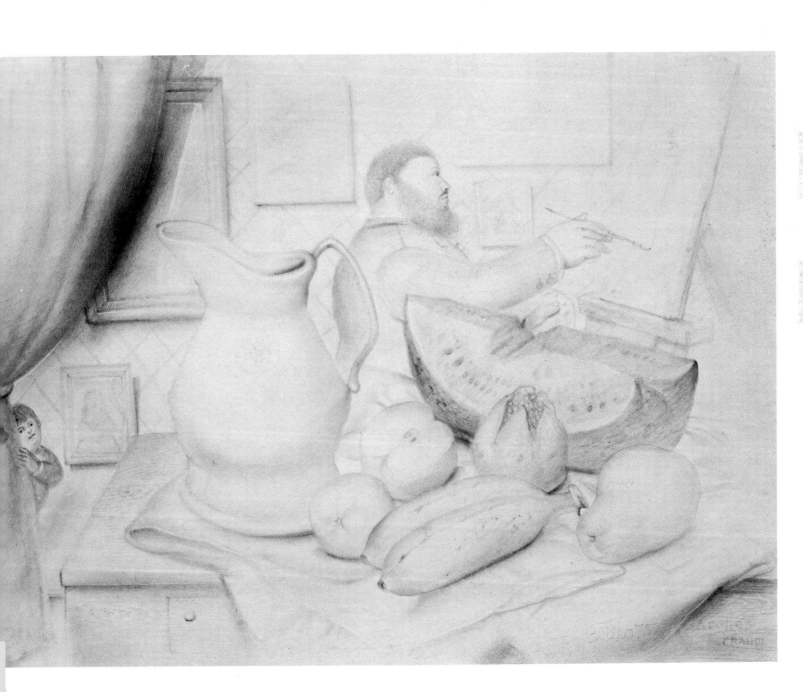

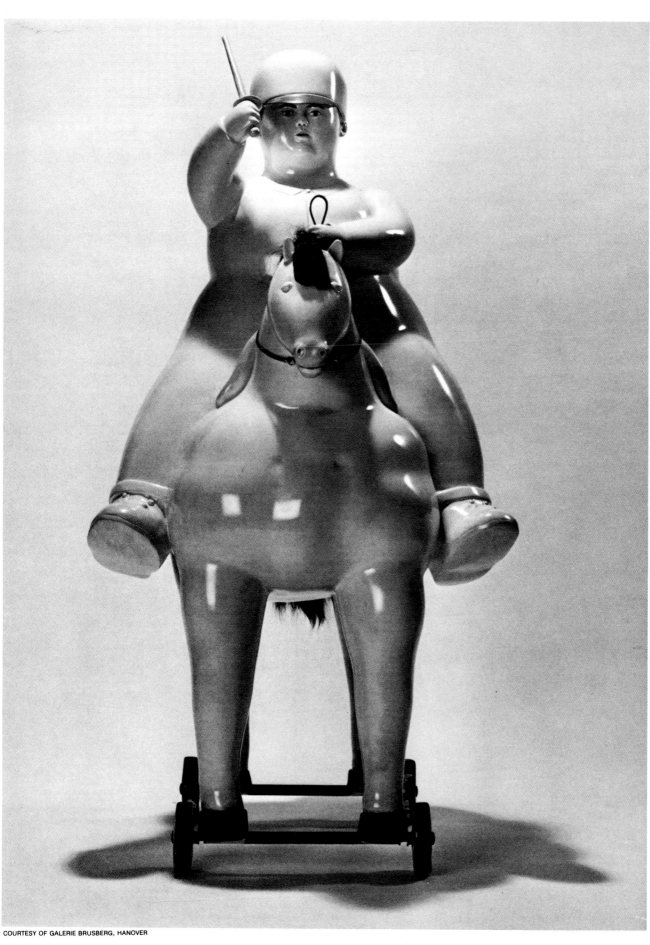

65.
Pedro on a Horse, 1977
Epoxy resin and synthetic hair (edition of 6),
153 x 90 x 80 (60¼ x 35⁷⁄₁₆ x 31½)
Marlborough Gallery, New York

Although the painting and the sculpture of
Pedro on a horse are very similar, Botero's inten-
tion was not to reproduce a painting in three
dimensions. He conceived of the sculpture in
profile, and the painting frontally.

Pedro, 1974
Oil on canvas, 194 x 150 (76½ x 59)
Sala Pedro Botero, Museo de Zea de Medellín
(not in exhibition)

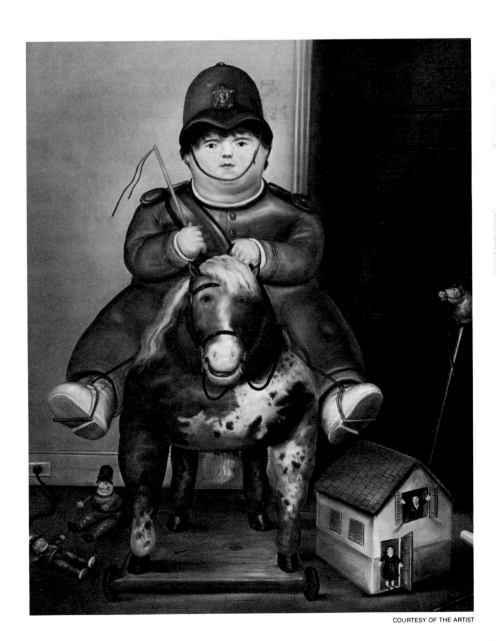

66.
The Musicians, 1979
Oil on canvas, 217 x 190 (85½ x 74¾)
Marlborough Gallery, New York
See front cover

"For some reason, I think that subject matter is very important. It is a pretext for doing things that otherwise you wouldn't do.

"The most beautiful American music, the most beautiful songs, usually come from musicals because there was a story to tell."

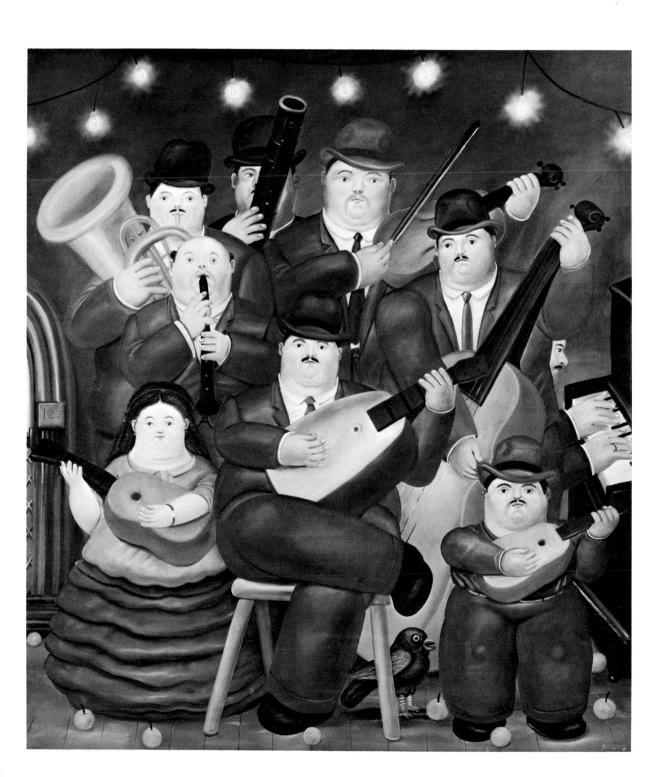

Selected Exhibitions

Anna Brooke

Exhibitions are arranged chronologically.

Exhibitions: Botero

1951

Fernando Botero, Galerías de Arte Foto-Estudio Leo Matiz, Bogotá, June 15–July 3, catalog, 25 works.

1952

Botero, Galerías de Arte de Leo Matiz, May, catalog, 23 works.

1955

Exposición de pintura de Fernando Botero, Biblioteca Nacional, Sala Gregorio Vásquez, Bogotá, May 12–26, checklist, 40 works (tour: Club de Profesionales, Medellín, Colombia, July 18–26).

1957

Galería Antonio Souza, Mexico City.

Fernando Botero of Colombia, Pan American Union, Washington, D.C., April 17–May 15, catalog, 31 works.

1958

Fernando Botero: Oleos, Galería Antonio Souza, February 13–28(?), checklist, 20 works.

Fernando Botero: Recent Oils, Watercolors, Drawings, Gres Gallery, Washington, D.C., October 30–November 25, catalog.

1959

Botero: Obras recientes, Biblioteca Nacional, Sala Gregorio Vásquez, November 5–21, catalog, 30 works.

1960

Botero, Gres Gallery, Washington, D.C., October 15–November 12, catalog.

1961

Botero, Galería de Arte El Callejón, Bogotá, June 26–July 10, 27 works.

1962

Botero, Gres Gallery, Chicago, February 15–March 10, catalog.

Botero, The Contemporaries, New York, November 6–24, catalog.

1964

Fernando Botero: Obras recientes, Museo de Arte Moderno, Bogotá, March 2–31(?), 33 works.

Fernando Botero: Bosquejos realidades, Galería Arte Moderno, Bogotá, checklist, 29 works.

1965

Botero: Recent Works, Zora Gallery, Los Angeles, April 25–May 15, catalog.

1966

Fernando Botero, Staatliche Kunsthalle, Baden-Baden, Germany, January 16–February 13, catalog text by Daniel Robbins, 23 works (tour: Galerie Buchholz, Munich, March 8–[?]).

Fernando Botero: Olbilder und Zeichnungen, Galerie Brusberg, Hanover, Germany, September 13–October 20, 35 works.

Fernando Botero: Recent Works, Milwaukee Art Center, December 1–January 15, 1967, catalog foreword by Tracy Atkinson, 24 works.

1968

Botero, Galería Juana Mordó, Madrid, February 5–24, catalog.

Botero, Galerie Buchholz, Munich, May 7–31, catalog introduction by Ernst Wuthenow, 21 works.

1969

Fernando Botero, Center for Inter-American Relations, New York, March 27–May 7, catalog foreword by Stanton L. Catlin, essay by Klaus Gallwitz, 22 works.

Botero: Peintures, pastels, fusains, Galerie Claude Bernard, Paris, September 29–November 9, catalog text by Fernando Arrabal, 16 works.

1970

Fernando Botero: Bilder 1962–1969, Staatliche Kunsthalle, Baden-Baden, March 20–May 3, catalog, 70 works (tour: Hause am Waldsee, Berlin; Städtische Kunsthalle, Düsseldorf, July 23–August 23; Kunstverein, Hamburg, August 29–September 27; Kunsthalle Bielefeld, October 11–November 22).

Fernando Botero, Hanover Gallery, London, October 6–November 20, catalog, 15 works.

1972

Fernando Botero, Marlborough Gallery, New York, February 5–29(?), catalog interview with Botero by Dr. Wibke von Bonin, 25 works.

Botero: Bleistiftzeichnungen, Sepiazeichnungen, Aquarelle, Galerie Buchholz, September 20–October 28, catalog, 43 works.

Botero: Pastels, fusains, sanguines, Galerie Claude Bernard, November 24–January 4(?), 1973, catalog introduction by Jean Paget, 15 works.

1973

Fernando Botero: Retrospectiva 1948–1972, Colegio San Carlos, Bogotá, January 23–27, catalog text by Tracy Atkinson, 32 works.

Fernando Botero, Marlborough Galleria D'Arte, Rome, April 10–May 8, catalog, 17 works.

1974

Fernando Botero: Aquarelle und Zeichnungen, Galerie Brusberg, Hanover, January 19–February 23, 44 works.

Botero, Sala de Arte, Biblioteca Pública Piloto, Medellín, July 12–27, catalog by Antonio Hernández Barrera.

Fernando Botero, Marlborough Galerie, Zurich, October–November, catalog, 16 works.

1975

Fernando Botero, Museum Boymans-van Beuningen, Rotterdam, March 27–May 19, catalog introduction by R. Hammacher-van den Brande, interview with Botero by Titia Berlage, 37 works.

Fernando Botero, Galería Adler Castillo, Caracas, June, checklist, 14 works.

Fernando Botero, Marlborough Gallery, New York, November 7–29, catalog introduction by Sam Hunter, 41 works (tour: Marlborough Godard, Toronto, December; Marlborough Godard, Montreal, February 1976).

1976

Botero: Aquarelles et dessins, Galerie Claude Bernard, March 18–April 28(?), catalog introduction by Severo Sarduy, 41 works.

Fernando Botero, Museo de Arte Contemporáneo, Caracas, April 2–May 31(?), catalog introduction by Sofía Imber, 38 works.

Botero, Pyramid Galleries, Washington, D.C., May–June, checklist.

Botero, Arte Independencia, la Galería de Colombia, Bogotá, August 16–(?), catalog text by Robert Pinzón.

1977

La Sala Pedro Botero, Museo de Arte de Medellín, September 16 (permanent installation), catalog text by Belisario Betancur, 16 works.

Botero: Sculptures, 4e Foire International d'Art Contemporain [FIAC], Grand Palais, Paris, October 22–30, organized by Galerie Claude Bernard, checklist, 13 works.

1978

Fernando Botero: Das plastische Werk, Galerie Brusberg, October 15–November 18, catalog text by Ursula Bode, 32 works (tour: Skulpturenmuseum der Stadt Marl, Germany, November 24–December 20).

1979

Fernando Botero, Galerie Isy Brachot, Knokke, Belgium, May 12–July 5, 21 works.

Fernando Botero, Musée d'Ixelles/Museum van Elsene, Brussels, June 28–September 16, catalog text by Marie-Françoise Carolus-Barré, 36 works (tour: Lunds Konsthall, Lund, Sweden, November–December; Sonja Henie-Neils Onstad Foundations, Høvikodden, Norway, February 7, 1980–March 16).

Fernando Botero, Galerie Claude Bernard, November 13–(?), 20 works.

Exhibitions: Botero and Others

1948

Exposición de pintores antioqueños, Palacio de Bellas Artes, Instituto de Bellas Artes, Medellín, 2 works.

1949

Salón de artistas antioqueños, Galerías de Arte, Universidad Nacional de Colombia, Extensión Cultural, Bogotá, May, 1 work.

1952

IX salón anual de artistas colombianos, Biblioteca Nacional, Bogotá, August 7–(?), 1 work.

1955

III bienal hispanoamericana de arte, Palacio Municipal de Exposiciones, Barcelona, September 24–January 6, 1956, Colombian section, nos. 4, 5.

Concurso de pintura de la Asociación de Escritores y Artistas de Colombia, Biblioteca Nacional, November 5–20, 1 work.

1956

Exposición inaugural, Galería El Caballito, Bogotá, March 23–April 13, 1 work.

Gulf-Caribbean Art Exhibition, Museum of Fine Arts, Houston, April 4–May 6, catalog foreword by Lee Malone, introduction by José Gómez-Sicre, no. 59 (tour: Dallas Museum of Fine Arts, June 3–July 13; Institute of Contemporary Art, Boston, September 12–October 21; Munson-Williams-Proctor Institute, Utica, N.Y., November 4–26; Carnegie Institute, Pittsburgh, December 18–January 15, 1957; Colorado Springs Fine Arts Center, February 3–March 18).

1957

X salón anual de artistas colombianos, Museo Nacional, Bogotá, October 12–November 11, catalog, nos. 18–20.

Salón de arte moderno, Biblioteca Luis-Angel Arango, Banco de la República, Bogotá, November 19–29, catalog, no. 3.

1958

Biennale internazionale d'arte XXIX, Venice, June 14–September 19, catalog, Colombian section, no. 4.

XI salón anual de artistas colombianos, Museo Nacional, September 12–October 12, catalog, nos. 21, 22.

Guggenheim International Award 1958, Solomon R. Guggenheim Museum, New York, October 22–February 23, 1959, catalog, 1 work.

1959

Paintings from the Gres Gallery, Baltimore Art Museum, February 8–March 8.

Salon de arte contemporáneo, Palacio de la Inquisición, Cartagena, Colombia, February 16–23, checklist, no. 2.

International Group Show, Gres Gallery, Washington, D.C., May (?)–June 13, 2 works.

Botero, Grau, Obregón, Ramírez, Villegas, Wiedemann, Galería de Arte El Callejón, Bogotá, May 7–22, catalog, 5 works.

V bienal de São Paulo, Museu de Arte Moderna, São Paulo, Brazil, September 1–December 21, catalog, Colombian section, nos. 1–5.

XII salón anual de artistas colombianos, Museo Nacional, September 16–October 7, catalog, nos. 8, 9.

South American Art Today, Dallas Museum of Fine Arts, October 10–November 29, catalog foreword by Jerry Bywater, introduction by José Gómez-Sicre, no. 36, circulated by American Federation of Arts (tour: J. B. Speed Art Museum, Louisville, Ky., January 5–25, 1960; Birmingham-Bloomfield Art Association, Birmingham, Mich., June 7–30; Tampa [Fla.] Art Institute, October 11–31; Joe and Emily Lowe Art Gallery, Syracuse [N.Y.] University, November 15–December 15; Wright Art Center, Beloit, Wisc., January 1–25, 1961).

1960

3500 Years of Colombian Art, Joe and Emily Lowe Art Gallery, University of Miami, Coral Gables, March 12–April 24, catalog text by Jay Pearson, nos. 357–59, sponsored by International Petroleum (tour: Pan American Union, Washington, D.C., June 21–July 10).

II anual interamericana de pintura, Centro Artístico, Barranquilla, Colombia, April 11–20, 2 works.

Salón nacional de pintura de Cúcuta, Cúcuta, Colombia, July 18–August 31(?), 3 works.

25 pinturas y relieves ("Los pintores autoexcluidos de la II bienal de México"), Biblioteca Luis-Angel Arango, Banco de la República, August 19–31, checklist, 10 works.

Gres Gallery, Washington, D.C., October 15–November 12.

Guggenheim International Award 1960, Solomon R. Guggenheim Museum, November 1–January 29, 1961, catalog, Colombian section, 1 work.

8 artistas modernos, Gallería El Callejón, December 2–18, 7 works.

1961

The Architect Selects, Gres Gallery, Washington, D.C., May.

International Selection 1961, Dayton [Ohio] Art Institute, September 16–October 15, catalog, nos. 8–13.

Recent Acquisitions: Painting and Sculpture, Museum of Modern Art, New York, December 19–February 25, 1962, checklist, comments by Alfred H. Barr, Jr., 1 work.

1962

Arte de Colombia, Galleria Nazionale d'Arte Moderna, Rome, March–April, catalog introduction by José Gómez-Sicre, nos. 114–16, organized by Esso Colombiano (tour: Liljevalchs Konsthall, Stockholm, April 27–May 20; Rautenstrauch-Joest-Museum der Städt Koln, June 16–August 12; Staatliche Kunsthalle, Baden-Baden, August 19–September 30; Sala de Exposiciones, Sociedad Española de Amigos del Arte, Madrid, November–December; Barcelona).

7 pintores contemporáneos, Galería Arte Moderno, Bogotá, April 12–May 31(?), catalog, 3 works.

Neo-Figurative Painting in Latin America, Pan American Union, April 13–May 6, catalog, no. 5.

Pintores colombianos: 2° festival nacional de arte Cali, La Tertulia, Cali, Colombia, June 18–25, 2 works.

1963

30 Colombian Painters, Fort Lauderdale Museum of the Arts, Schramm Galleries, and The Gallery, joint exhibition, February.

23 pinturas colombianas: Colección de la Biblioteca Luis-Angel Arango del Banco de la República, Sala de Exposiciones, Banco de la República, Cúcuta, February 16–23, catalog, no. 3 (tour: Sala de Exposiciones, Banco de la República, Bucaramanga, February 16–23; Sala de Exposiciones, Club Magdalena en la Refinería de Ecopetrol, Barrancabermeja, March 2–9).

Galería Arte Moderno, Bogotá, April, 1 work.

Arte de América y España, Palacios de Velázquez y Cristal del Retiro, Madrid, May–June, catalog, nos. 37–39, organized by the Instituto de Cultura Hispánica de Madrid (tour: Antiguo Hospital de la Santa Cruz and Palacio de la Virreina, Barcelona, August–September).

3er festival nacional de arte—1963, exposiciones: Primer salón gran colombiano de pintura, Palacio de Bellas Artes, Cali, June 14–25.

Südamerikanische Malerei der Gegenwart, Haus der Städtischen Kuntstammlungen, Bonn, June 30–September 1, catalog text by Will Grohmann, nos. 36–38, organized by Galerie Buchholz, Munich (tour: Akademie der Künste, Berlin, January 12–February 9, 1964; Staatliche Kunsthalle, Baden-Baden, March; Kunst und Kunstgewerbeverein Pforzheim, Reuchlinhaus, April 12–May 3; Galerie Buchholz, Munich, January 8–February 13, 1965; Fränkische Galerie, Nuremberg, March 21–April 19).

El siglo XX y la pintura en Colombia, Museo Nacional, August 4–(?), catalog text by Eugenio Barney Cabrera, no. 39.

1964

Painters Resident in the U.S.A. from the Latin Americas, Institute of Contemporary Arts, Washington, D.C., April 10–May 29, catalog, no. 3.

IV festival nacional de arte—Cali: Primer salón de pintura y escultura, Palacio de Bellas Artes, Cali, June 19–30.



114

Figuratie Defiguratie: De Menselijke Figuur Sedert Picasso, The Human Figure since Picasso, Museum voor Schone Kunsten, Ghent, July 10–October 4, catalog, no. 42.

Primer salón Intercol de artistas jóvenes, Museo de Arte Moderno, Bogotá, July 21–August 31(?), catalog introduction by José Gómez-Sicre, nos. 4, 5.

Magnet: New York, Galería Bonino, New York, September 21–October 10, catalog, nos. 8, 9.

II bienal americana de arte, Ciudad Universitaria, Córdoba, Argentina, September 25–October 12, catalog, 1 work.

The Dark Mirror, selected by Charles Addams, catalog, no. 5, circulated by American Federation of Arts (tour: State University of New York, College at Fredonia, October 8–29; University of Manitoba, Winnipeg, Canada, November 12–December 3; University of British Columbia, Vancouver, January 21–February 11, 1965; Harpur College, State University of New York at Binghamton, April 1–22; Museum of Art, Science and Industry, Bridgeport, Conn., May 6–27; American Federation of Arts, New York, June 22–July 8; Paul Sargent Gallery, Eastern Illinois University, Charleston, July 22–August 19; Coe College, Cedar Rapids, Iowa, October 7–28).

1964 Pittsburgh International, Museum of Art, Carnegie Institute, Pittsburgh, October 30–January 10, 1965, catalog foreword by Gustave von Groschwitz, no. 40.

6 artistas colombianos contemporáneos, Galería 25, Bogotá, November 25–(?).

1965

International '65: A Selection from the 1964 Pittsburgh International, part one, J. L. Hudson Gallery, Detroit, February 10–March 6, catalog preface by Albert Landry, no. 11.

Esso Salon of Young Artists, Pan American Union, April 25–May 18, catalog introduction by José Gómez-Sicre, no. 8.

The Emergent Decade: Latin American Painting, Solomon R. Guggenheim Museum, May 20–June 19, catalog introduction by Thomas M. Messer, 2 works (tour: Andrew Dickson White Museum of Art, Cornell University, Ithaca, N.Y., October 8–November 8; Dallas Museum of Fine Arts, December 18–January 18, 1966; National Gallery of Canada, Ottawa, April 1–May 1; Krannert Art Museum, Urbana, Ill., September 18–October 9; De Cordova Museum, Lincoln, Mass., November 6–December 4; John and Mable Ringling Museum of Art, Sarasota, Fla., April 9–May 7, 1967).

1966

Art of Latin America since Independence, Yale University Art Gallery, New Haven, Conn., January 27–March 13, catalog by Stanton Loomis Catlin and Terence Grieder, no. 49 (tour: University Art Museum, University of Texas at Austin, April 17–May 15; San Francisco Museum of Art, July 2–August 7; La Jolla [Calif.] Museum of Art, August 27–September 30; Isaac Delgado Museum of Art, New Orleans, October 29–November 27).

Pintura colombiana de ayer y de hoy, Biblioteca Luis-Angel Arango, Banco de la República, August 5–20.

Arte hispanoamericano contemporáneo, colección privada, Museo de la Universidad de Puerto Rico, Rio Piedras, September 13–October 7, catalog text by Ramón Osuna Plá, no. 13.

Latin American Perspective, Greenwich [Conn.] Library, November 2–22, 1 work.

1967

Latin American Art, 1931–1966: Selected from the Permanent Collection, Museum of Modern Art, March 17–June 4, checklist, 1 work.

Cinquième biennale de Paris: Manifestation biennale et internationale des jeunes artistes, Musée d'Art Moderne de la Ville de Paris, September 29–November 5, catalog, Colombian section, nos. 1–3.

1967 Pittsburgh International Exhibition of Contemporary Paintings and Sculpture, Museum of Art, Carnegie Institute, October 27–January 7, 1968, catalog foreword by Gustave von Groschwitz, no. 30.

A Salute to Latin American Art, Michael Berger Gallery, Pittsburgh, October 27–November 12, checklist, 3 works.

1968

4 Latin American Painters, Art Gallery, State University of New York at Stony Brook, March 21–April 5, catalog, 5 works.

Paintings by Fernando Botero and Leopold Richter, Walter Engel Gallery, Toronto, April 7–30, catalog, nos. 1–4.

Pintura, escultura y tapicería de Colombia, Biblioteca Luis-Angel Arango, Banco de la República, April 19–30, catalog, nos. 1, 2.

Menschenbilder, Kunsthalle, Darmstadt, Germany, September 14–November 17, catalog preface by Ludwig Engel, nos. 19, 20.

Latin American Artists, Walter Engel Gallery, October 20–November 9, catalog, 3 works.

1969

Inflated Images, Museum of Modern Art Circulating Exhibition, catalog text by Betsy Jones, nos. 3, 4 (tour: Mercer [Ga.] University, January 6–27; Witte Memorial Museum, San Antonio, Tex., February 16–March 8; Portland [Ore.] Art Museum, April 1–29; Georgia Museum of Art, University of Georgia, Athens, July 1–22; Andrew Dickson White Museum of Art, Cornell University, September 4–25; Goucher College, Towson, Md., October 10–31; University of Manitoba, Winnipeg, Canada, November 30–December 21; Edmonton [Canada] Art Gallery, January 5–26, 1970).

Contemporary Portraits, Museum of Modern Art Circulating Exhibition, catalog text by Alicia Legg, no. 7 (tour: University of Connecticut, Storrs, February 2–23; Flint [Mich.] Institute of Arts, March 21–April 13; J. B. Speed Art Museum, Louisville, Ky., April 28–May 26; Kresge Art Center, Michigan State University, East Lansing, July 6–August 3; University of North Carolina, Greensboro, October 3–24; Cummer Gallery of Art, Jacksonville, Fla., December 8–January 5, 1970; Middlebury [Vt.] College, February 1–22).

Nueve obras de la pintura contemporánea Colombiana, Galería Buchholz, Bogotá, June 27–July 22, catalog by Franz Vila, 1 work.

Latin American Paintings from the Collection of the Solomon R. Guggenheim Museum, Art Gallery, Center for Inter-American Relations, New York, July 2–September 14, catalog foreword by Stanton L. Catlin, preface by Thomas M. Messer, 1 work.

Contemporary Latin American Painting, Philbrook Art Center, Tulsa, Okla., October 7–28, catalog introduction by José Gómez-Sicre, 1 work (tour: Oklahoma Art Center, Oklahoma City, November 2–30; Museum of Art, University of Oklahoma, Norman, December 7–21).

1970

Il bienal de arte Coltejer, Museo, Universidad de Antioquia, Medellín, May 1–June 25, 1 work.

Botero, Cuevas: Paintings, Drawings, Walter Engel Gallery, May 10–June 7, catalog, 4 works.

Latin American Paintings and Drawings from the Collection of John and Barbara Duncan, Art Gallery, Center for Inter-American Relations, July 9–August 30, catalog introduction by Barbara Duncan, no. 8, circulated by International Exhibitions Foundation (tour: Pyramid Galleries, Washington, D.C., September 15–October 17, 1971; Texas Tech University Museum, Lubbock, October 23–November 14; University Art Museum, University of Texas at Austin, December 1–31; Munson-Williams-Proctor Institute, February 1–29, 1972; Arkansas Arts Center, Little Rock, May 1–31; Montgomery [Ala.] Museum of Fine Arts, June 15–July 16; Abilene [Tex.] Fine Arts Museum, August 1–31; Tennessee Botanical Gardens and Fine Arts Center, Nashville, September 15–October 15; Fort Lauderdale [Fla.] Museum of the Arts, November 1–30).

Botero, Coronel, Rodòn, Museo de la Universidad de Puerto Rico, November 13–December 9, catalog text by Marta Traba, 11 works.

Esso Salon of Contemporary Latin American Artists: A New Permanent Collection, Joe and Emily Lowe Art Gallery, University of Miami, December 9–January 31, 1971, catalog preface by John J. Baratti, introduction by José Gómez-Sicre, no. 49.

1971

12 Artists from Latin America, John and Mable Ringling Museum of Art, January 11–February 7, catalog introduction by Leslie Judd Ahlander, nos. 11–13.

Botero, Lindner, Wesselmann: Aus gewählte Bilder, Zeichnungen und Grafik, Galerie Brusberg, Hanover, April 23–June 1, 8 works.

117 dessins et gravures de peintres d'Amérique Latine, Le Centre de Recherches Latino Américanes, Université de Poitiers, France, May 14–June 4, 3 works.

1972

A Selection of European and American Watercolors and Drawings, Marlborough Gallery, New York, March–April, catalog, nos. 8, 9 (tour: Marlborough Galerie, Zurich, April–June).

Looking South, Latin American Art in New York Collections, Center for Inter-American Relations, May 16–July 28, catalog, no. 4.

1973

Botero, Akawie, Pyramid Galleries, March 6–April 3.

32 artistas colombianos de hoy, Museo de Arte Moderno, Bogotá, April, catalog.

Rasgos y trazos, Galería Arte Moderno, Bogotá, October 10–(?).

1974

Art of the Americas in Washington Private Collections, Organization of American States, Washington, D.C., March 15–April 7, catalog introduction by José Gómez-Sicre, 1 work.

Arte colombiano de hoy, Sala de Exposiciones, Fundación Eugenio Mendoza, Caracas, June–July, catalog text by Lourdes Blanco, nos. 11, 12.

Inaugural Exhibition, Hirshhorn Museum and Sculpture Garden, Smithsonian Institution, Washington, D.C., October 4–September 15, 1975, 1 work.

Arte y política, Museo de Arte Moderno, Bogotá, October 22–November 22, catalog text by Darío Ruiz Gómez and Eduardo Serrano, no. 54.

1975

Der Einzelne und die Masse: Kunstwerke des 19. und 20. Jahrhunderts, Städtische Kunsthalle Recklinghausen, Germany, May 22–July 10, catalog preface by Thomas Grochowiak, 1 work.

Paisaje 1900–1975, Museo de Arte Moderno, Bogotá, July, catalog text by Eduardo Serrano, 3 works.

Panorama of Contemporary Latin American Artists, New Jersey State Museum, Trenton, September 5–October 27, catalog text by Ernesto J. Ruíz de la Mata, no. 6, circulated by the New Jersey State Council on the Arts (tour: Glassboro State College, November 8–December 20; Bergen Community Museum of Arts and Sciences, Paramus, January 10–February 29, 1976; Rutgers University, New Brunswick, March 13–April 17; Stockton State College, Pomona, May 15–July 4).

Grandes artistas del siglo XX, Galería Meindl, Bogotá, October.

L' art colombien à travers les siècles, Musée du Petit Palais, Paris, November 7–February 15, 1976, catalog preface by Gloria Zea de Uribe, no. 568, organized by the Instituto Colombiano de Cultura (tour: Palacio Velázquez del Retiro, Madrid, April 8–May 31(?); Reales Atarazanas, Barcelona, June 14–30, 559, 560).

1976

Gran formato, Galería Theo, Madrid, January–February, catalog text by Antonio Bonet Correa, 1 work.

1ᵉ certamen internacional de artes plasticas/ First International Exhibition of Plastic Arts, Museo Internacional de Arte Contemporáneo, Lanzarote, Canary Islands, catalog, 1 work.

Colección Banco Cafetero, Museo de Arte Moderno, Bogotá, March 17–April 10, 1 work.

Studio f Sammlung Kurt Fried, Ulmer Museum, Germany, March 21–May 16, catalog, introduction by Erwin Treu, nos. 46, 47.

Latin American Horizons: 1976, John and Mable Ringling Museum of Art, April 8–May 16, catalog preface by Richard S. Carroll, introduction by Leslie Judd Ahlander, 1 work (tour: Metropolitan Museum and Art Centers, Miami, May 28–June 30; Pensacola Art Center, July 15–August 15; Museum of Fine Arts, St. Petersburg, September 1–October 1; Fort Lauderdale Museum of the Arts, November 1–30).

Inaugural Exhibition, Grey Art Gallery and Study Center, New York University, September 22–October 16, catalog foreword by Kenneth L. Mathis, 1 work.

Artistas colombianos residentes en Paris, Centro del Café de Colombia, Paris, October 26–November 16.

Recent Work: Arikha, Auerbach, Bacon, Botero, Genoves, Grooms, Katz, Kitaj, López-García, Rivers, Marlborough Gallery, New York, November 30–December 31, catalog, 2 works.

1977

Recent Latin American Drawings (1969–1976) Lines of Vision, catalog essays by Barbara Duncan and Damián Bayón, no. 17, circulated by International Exhibitions Foundation (tour: Center for Inter-American Relations, February 15–March 20; Florida International University, Miami, April 15–May 15; Arkansas Arts Center, Little Rock, August 1–September 18; University Art Museum, University of Texas at Austin, October 1–November 15; Oklahoma Art Center, December 1–January 15, 1978; Metropolitan Museum of Manila, Philippines, February 1–March 15; Art Gallery of Hamilton, Ontario, Canada, April 7–May 15; Indianapolis Museum of Art, June 1–July 16; Art Gallery, Inter-American Development Bank, Washington, D.C., August 7–31; Vassar College Art Gallery, Poughkeepsie, N.Y., October 1–November 15; Anchorage [Alaska] Historical and Fine Arts Library, December 1–January 15, 1979; Munson-Williams-Proctor Institute, February 1–March 15).

La figura femenina en nuestro arte, Galería Buchholz, Bogotá, August 24–September 30.

Fall 1977: Contemporary Collectors, Aldrich Museum of Contemporary Art, Ridgefield, Conn., September 25–December 18, catalog preface by Robert Faesy, introduction by Charles Dyer, 1 work.

1978

The Big Still Life, Allan Frumkin Gallery, New York, February 10–March 9, catalog introduction by Allan Frumkin, 1 work.

The 1978 Latin American Art Exposition, De Armas Gallery, Virginia Gardens, Fla., March 31–May 19, catalog, 1 work.

Masters of Modern Sculpture, Marlborough Gallery, New York, May 6–June 17, catalog, nos. 53, 54.

The Colombian Exposition, De Armas Gallery, May 26–July 7, catalog preface by Willy A. Bermello, 2 works.

Tenth Anniversary Show, Walter Engel Gallery, September 17–October 31, catalog, 4 works.

Mona Lisa im 20. Jahrhundert, Wilhelm-Lehmbruck-Museum der Stadt Duisberg, Germany, September 24–December 3, catalog, 1 work (tour: Württenbergischer Kunstverein, Stuttgart, December 13–January 14, 1979).

1979

Kunst der letzten 30 Jahre, Museum des 20. Jahrhunderts, Vienna, April 27–October 31(?), 1 work.

Summer Loan Exhibition, Metropolitan Museum of Art, New York, July 17–September 30, checklist, 1 work.

Selected Bibliography

Anna Brooke

Works are arranged chronologically. Exhibition catalogs are listed under Selected Exhibitions (pp. 111-16).

Articles by Botero

"Picasso y la inconformidad en el arte." *El Colombiano* (Medellín), Supplement, July 17, 1949, p. 3.

"Anatomía de una locura." *El Colombiano,* Supplement, August 7, 1949, p. 4.

Illustrations by Botero

El Colombiano, Supplement, 1949: April 24, p. 3; May 8, p. 2; May 12, p. 3; May 15, p. 4; May 19, p. 4; May 29, pp. 1, 4; June 12, p. 2; July 3, p. 3; July 10-31, p. 4; July 17, p. 3; July 24, p. 3.

Gabriel García Márquez. "La siesta del martes." *El Tiempo* (Bogotá), Lecturas Dominicales, January 24, 1960, p. 1.

Monographs

Engel, Walter. *Botero.* Bogotá: Los Libros de Eddy Torres, 1952.

Gallwitz, Klaus. *Botero.* Munich: Edition Galerie Buchholz, 1970.

Rivero, Mario. *Botero.* Barcelona: Plaza & Janés, 1973.

Gallwitz, Klaus. *Fernando Botero.* Translated by John Gabriel. New York: Rizzoli; London: Thames & Hudson, 1976 (published simultaneously in German by Verlag Gerd Hatje, Stuttgart).

Arciniegas, Germán. *Fernando Botero.* Translated by Gabriela Arciniegas. New York: Abrams, 1977 (first published in Spanish, Madrid: Edilerner, 1973).

Bode, Ursula. *Fernando Botero: Das plastische Werk.* Hanover: Galerie Brusberg, 1978.

Periodicals: Botero

"Artista nuevo." *El Colombiano* (Medellín), Supplement, April 24, 1949, p. 1.

Engel, Walter. "Fernando Botero." *El Tiempo* (Bogotá), Magazine Dominical, June 8, 1952.

"Pintor tropical." *Visión* (Mexico City), June 24, 1952, p. 32.

Jebec. "Pintura de Fernando Botero." *La República* (Bogotá), May 15, 1955, p. 9.

Engel, Walter. "La pintura de Fernando Botero." *El Tiempo,* May 22, 1955.

Zuleta, Estanislao. "Consideraciones sobre la pintura y sobre la obra de Fernando Botero." *Universidad de Antioquia* (Medellín), no. 122 (June–August 1955), pp. 553-61.

"La aparición de un maestro precoz, Fernando Botero, figuras, caballos y espacios. . . ." *Semana* (Bogotá), no. 448 (June 6, 1955), p. 32.

Portner, Leslie Judd. "Art in Washington." *Washington Post and Times Herald,* April 28, 1957, sec. F, p. 7.

Berryman, Florence. "Artists and Exhibitions: Monumental Forms." *Sunday Star* (Washington, D.C.), May 12, 1957, sec. E, pp. 15, 17.

Traba, Marta. "Un gran cuadro en el Salón Nacional." *El Tiempo,* September 14, 1958, p. 2.

"El XI salón anual de artistas colombianos, por decisión unánime se otorgó el primer premio a Fernando Botero." *El Tiempo,* September 14, 1958, p. 12.

Portner, Leslie Judd. "Good Shows at Jefferson and Gres." *Washington Post and Times Herald,* November 9, 1958, sec. E, p. 7.

"La pintura de Fernando Botero." *Estampa* (Bogotá), no. 1045 (November 16-22, 1958), pp. 5-7.

Zalamea, Jorge. "Botero." *Cromos* (Bogotá), no. 2215, November 23, 1959.

Muñoz Jiménez, Fernán. "Mons. Félix Henao inspirador de Arzodiabolomaquía." *El Espectador* (Bogotá), June 5, 1960.

Vivas, Nelly. "Cuadro de Fernando Botero en el Museo de Arte Moderno de Nueva York." *El Tiempo,* December 31, 1961.

Kroll, Jack. "Reviews and Previews, New Names This Month: Fernando Botero." *Art News* 61 (December 1962): 20.

Judd, Donald. "New York Exhibitions: In the Galleries." *Arts Magazine* 37 (January 1963): 55.

"Mona Lisa Age Twelve by Fernando Botero 1959." *Cosmopolitan* 153 (December 1963): 94.

Traba, Marta. "Yo entrevisto a Fernando Botero." *El Espectador,* Magazine Dominical, March 1, 1964, sec. E, p. 8.

Engel, Walter. "La marca 'Botero.'" *El Espectador,* Magazine Dominical, March 15, 1964.

Arango, Gonzalo. "Discurso para Botero: En la Galería de Arte Moderno." *El Tiempo,* Lecturas Dominicales, August 22, 1965, p. 7.

Haller, Elsbeth. "Monstren, Schattenbilder und Requisiten. Drei Künstler in der Staatlichen Kunsthalle, Baden-Baden." *Badisches Tagblatt* (Baden-Baden), January 27, 1966.

Rivero, Mario. "De la bella al monstruo." *El Tiempo,* Magazine Dominical, February 13, 1966, sec. E, p. 15.

Key, Donald. "Soft Satirical Style Is Introduced by Art Center's Botero Exhibition." *Milwaukee Journal,* December 4, 1966.

"Piñatas in Oil." *Time* 88 (December 30, 1966): 26–27.

Lastra, Luis. "Fernando Botero, la raíz del recuerdo." *Panorama* (Bogotá), May 14, 1967.

"Botero y su obra." *Visión,* February 16, 1968, pp. 44–45.

Gallwitz, Klaus. "Fernando Botero." *Das Kunstwerk* (Stuttgart) 21 (April–May 1968): 3–13.

"Botero: Feiste Elsbeth." *Der Spiegel* (Hamburg), no. 23 (June 3, 1968), pp. 109–10.

"Fernando Botero: Neue Olbilder." *Brusberg-Berichte* 5 (Hanover), 1969, p. Q 42.

Canaday, John. "Fernando Botero." *New York Times,* March 29, 1969, sec. 1, p. 31.

Barnitz, Jacqueline. "Three Artists at the C.I.R.: Ramírez, Macció and Botero in New York." *Arts Magazine* 43 (April 1969): 42–44.

Schjeldahl, Peter. "New York Letter." *Art International* 13 (May 20, 1969): 38.

Isaacs, Cecilia. "Botero y su obra." *Visión*, May 23, 1969, p. 40.

Robarts, Jacqueline Z. "On Exhibition: France and Switzerland." *Studio International* 178 (July–August 1969): 37.

Peppiatt, Michael. "Paris." *Art International* 13 (Christmas 1969): 77–78.

Sello, Gottfried. "Botero, Ausstellung in Baden-Baden: Paradies der Dicken." *Die Zeit* (Hamburg), April 3, 1970, no. 14.

Romain, Lothar. "Fernando Botero." *Das Kunstwerk* 23 (June–July 1970): 78.

Burr, James. "London Galleries: The New Vocabulary of Space, Movement and Light." *Apollo* 92 (October 1970): 307.

Asmodi, Herbert. "Botero: Ein Interview von Herbert Asmodi." *Die Kunst und das schöne Heim* (Munich) 82 (November 1970): 668–70.

Barnitz, Jacqueline. "Botero: Sensuality, Volume, Colour." *Art and Artists* 5 (December 1970): 50–53.

Denvir, Bernard. "London Letter." *Art International* 14 (Christmas 1970): 52–54.

"Botero, Lindner, Wesselmann: Aus gewählte Bilder, Zeichnungen und Grafik." *Brusberg-Berichte* 12 (Hanover) (1971), pp. 43–45.

"The Fat World of Fernando Botero." *The Blade* (Toledo, Ohio), Sunday Magazine, April 25, 1971, pp. 8–9, 12–13.

Schjeldahl, Peter. "Surrealist Fernando Botero Deflates the Effete and the Elite." *New York Times,* February 20, 1972, sec. 2, p. 19.

Gerrit, Henry. "Reviews and Previews: Fernando Botero." *Art News* 71 (March 1972): 12.

Wolmer, Denise. "In the Galleries." *Arts Magazine* 46 (April 1972): 66.

Ratcliff, Carter. "New York Letter." *Art International* 16 (April 20, 1972): 34–35.

Paget, Jean. "Botero en Paris." *El Tiempo,* Magazine Dominical, November 18, 1972, p. 13.

Roh, Juliane. "Zeichnungen von Fernando Botero." *Das Kunstwerk* 25 (November 18, 1972), p. 13.

Barotte, René. "Botero, du gigantisme à la tendresse." *L' Aurore* (Paris), December 27, 1972, p. 7.

Muth, Helga. "Botero." *Das Kunstwerk* 26 (January 1973): 65.

"Un falso ingenuo: Botero." *Goya* (Madrid) 112 (January–February 1973): 236.

Peppiatt, Michael. "Paris: Mid-December." *Art International* 17 (February 1973): 27.

Touraine, Liliane. "Lettre de Paris." *Art International* 17 (April 1973): 72.

de Montaña, Inés. "El Vaticano compró un cuadro de Botero." *El Espectador,* April 6, 1973.

"Around the European Galleries and Museums: Paris/Botero." *International Herald Tribune,* April 28–29, 1973, p. 7.

Rivero, Mario. "Botero." *Revista Diners* (Bogotá), June–July 1973, p. 47.

Rivero, Mario. "Botero: El oficio de pintor." *El Espectador,* Magazine Dominical, June 10, 1973.

Vila, Franz. "Rubens y Botero." *La República,* August 5, 1973.

Gallwitz, Klaus. "Introducción a Botero." *ECO* (Bogotá) 27 (December 1973): 172–80.

Medina, Alvaro. "Botero encuentra a Botero." *ECO* 27 (December 1973): 181–202. Republished in *Procesos del arte en Colombia,* Bogotá: Instituto Colombiano de Cultura, 1978.

Undiano, Federico. "Fernando Botero." *Mundo hispánico* (Madrid) 27 (January 1974): 28–31.

Bode, Ursula. "Zeichnungen wie ruhige Atemzüge: Eine neue Dimension im Werk Boteros." *Brusberg-Berichte* 18 (April 1974), pp. 45–84.

de Montaña, Inés. "Pedrito Botero: Un cuadro inconcluso." *El Espectador,* April 20, 1974, sec. A, p. 14.

Hernández, Jesús. "Sepultado hijo del pintor Fernando Botero en Cali." *El Espectador,* April 25, 1974, sec. A, p. 12(?).

Apuleyo Mendoza, Plinio. "Botero: De pintor a escultor." *El Espectador,* June 30, 1974.

Hocke, Gustav René. "Fernando Botero: A Continent under the Magnifying Glass." *Art International* 18 (December 1974): 19–21, 34.

"Fernando Botero." *Bulletin Museum Boymans-van Beuningen Rotterdam,* no. 16 (April 1975), pp. 122–23.

Arango, Gonzalo. "Botero y yo." *El Tiempo,* April 27, 1976.

Parinaud, André. "L' aventure de l'art moderne: Botero par Botero." *Galerie Jardin des Arts: Revue Mensuelle* (Paris), no. 166 (February 1977), pp. 13–[27].

Arciniegas, Germán. "Tercera dimensión de Botero." *El Tiempo,* February 28, 1977.

Shirey, David L. "Among the Books, 8 Compelling Canvases." *New York Times,* July 10, 1977, sec. 21, p. 14.

Estrada, Leonel. "La Sala Pedrito Botero." *El Tiempo,* September 19, 1977, sec. A, pp. 4, 7.

"Fernando Botero explica su pintura." *El Tiempo,* July 30, 1978, sec. B, p. 3.

Martínez, María Eugenia. "Mi Columna: Botero con la Liga." *El Siglo* (Bogotá), November 22, 1978.

Winter, Peter. "Fernando Botero." *Das Kunstwerk* 31 (December 1978): 65–66.

Gómez-Sicre, José. "Fernando Botero." *Re-Vista* (Medellín) 1 (May 1979): 39–42.

Books: Botero and Others

Traba, Marta. *Colombia: Art in Latin America Today.* Washington, D.C.: Pan American Union, 1959.

―――. *La pintura nueva en Latinoamérica.* Bogotá: Librería Central, 1961.

Diaz, Hernán, and Traba, Marta. *Seis artistas contemporáneos colombianos.* Bogotá: Alberto Barco, 1963.

Ortega Ricaurte, Carmen. *Diccionario de artistas en Colombia.* Bogotá: Ediciones Tercer Mundo, 1965.

Messer, Thomas M. *The Emergent Decade: Latin American Painters and Painting in the 1960's.* Ithaca: Cornell University Press, 1966.

Arte y artistas de Colombia. Bogotá: G. Paez D. Editores, 1972.

Traba, Marta. *Dos décadas vulnerables en las artes plásticas latinoamericanas 1950–1970.* Mexico City: Siglo Veintiuno Editores, 1973.

Bayón, Damián. *América Latina en sus artes.* Mexico City: Siglo Veintiuno Editores, 1974.

Traba, Marta. *Historia abierta del arte colombiano.* Cali: Museo de Arte Moderno, La Tertulia, 1974.

Jiménez Gómez, Carlos. *Retrato de familia: Una biografia de nuestra transición.* Bogotá: Editorial Visión Fotolitografía, 1975.

Panesso, Fausto. *Los intocables: Botero, Grau, Negret, Obregón, Ramírez V.* Bogotá: Ediciones Alcaravan, 1975.

Hunter, Sam, and Jacobus, John. *Modern Art.* New York: Abrams, 1976.

Serrano, Eduardo. *Un lustro visual: Ensayos sobre arte contemporáneo colombiano.* Bogotá: Ediciones Tercer Mundo, 1976.

Traba, Marta. *Mirar en Bogotá.* Bogotá: Instituto Colombiano de Cultura, Biblioteca Básica Colombiana, 1976.

Barney-Cabrera, Eugenio, and Mallarino de Rueda, Silvia. *Historia del arte colombiano.* 7 vols. Bogotá: Salvat Editores Colombiana, 1977, vol. 7.

Periodicals: Botero and Others

"El décimo salón de artistas colombianos." *Vínculo Shell* (Bogotá), December 1957, pp. 25–29.

Gómez Jaramillo, Ignacio. "Estado de la pintura colombiana." *El Tiempo* (Bogotá), May 25, 1958.

"Preludios de salón." *Semana* (Bogotá), September 9–15, 1958, pp. 42–43.

Berryman, Florence. "Washington Artists Open 66th Annual." *Washington Star,* February 8, 1959, sec. E, p. 5.

"Baltimore Museum: Paintings from the Gres Gallery." *Washington Post and Times Herald,* March 8, 1959, sec. E, p. 7.

Ahlander, Leslie Judd. "Beautiful Group Exhibition at Gres." *Washington Post and Times Herald,* June 7, 1959, sec. E, p. 7.

Traba, Marta. "Pan America: Five Contemporary Colombians." *Art in America* 48 (Spring 1960): 110–11.

Engel, Walter. "La pintura de hoy en Colombia." *Plástica* (Bogotá), no. 17 (May–December 1960), p. 3.

Ahlander, Leslie Judd. "An Architect's Selection of Art." *Washington Post,* May 21, 1961, sec. G, p. 6.

The Bulletin of The Museum of Modern Art 29 (1962): 52, 58.

"Contemporary Art of Colombia." *Art in America* 51 (April 1963): 106–7.

Berkowitz, Marc. "Arte de América y España." *Das Kunstwerk* (Stuttgart) 17 (August–September 1963): 36, 57–58.

Squirru, Rafael. "Spectrum of Styles in Latin America." *Art in America* 52 (February 1964): 81–86.

Rosenthal, Nan. "New York: Around the World in 20 Galleries." *Art in America* 52 (October 1964): 119–21.

Gómez-Sicre, José. "El primer salón Intercol." *Lámpara* (Bogotá) 10 (November 1964): 2–3.

Traba, Marta. "Colombia Year Zero." *Art International* 9 (June 1965): 16–19.

Cranfill, Thomas M. "The Braniff International Airways Collection." *Texas Quarterly* 8 (Autumn 1965): special section, 2, 57, 185.

Gómez-Sicre, José. "A Survey of South American Art." *Texas Quarterly* 8 (Autumn 1965): 10.

Traba, Marta. "A View of Contemporary Art in Colombia." *Texas Quarterly* 8 (Autumn 1965): 54.

Messer, Thomas M. "Latin America: Esso Salon of Young Artists." *Art in America* 53 (October–November 1965): 120–21.

Engel, Walter. "La pintura de postguerra." *Espiral* (Bogotá), nos. 111–12 (September–December 1969), pp. 50–52, 66.

Butler, Joseph T. "The American Way with Art: Neighbors to the North and South." *Connoisseur* 177 (May 1971): 57–58.

Preston, Malcolm. "Innovative Contrasts." *Newsday* (Long Island), June 16, 1971.

Canaday, John. "Good Art, Weak Adversary." *New York Times,* July 11, 1971, sec. D, p. 21.

Richard, Paul. "A Colorful Tradition: Galleries." *Washington Post,* March 14, 1973, sec. B, p. 11.

"Arte y política." *El Tiempo,* October 20, 1974, sec. B, p. 6.

Castro Montero, Roberto. "Soto y Botero: Un análisis de la realidad en dos tiempos." *El Universal* (Caracas), April 13, 1976, sec. 1, p. 18.

Sanjurjo de Casciero, Annick. "Lines of Vision." *Américas* (Washington, D.C.) 31 (February 1979): 2–8.